W9-CAL-118

Orange County

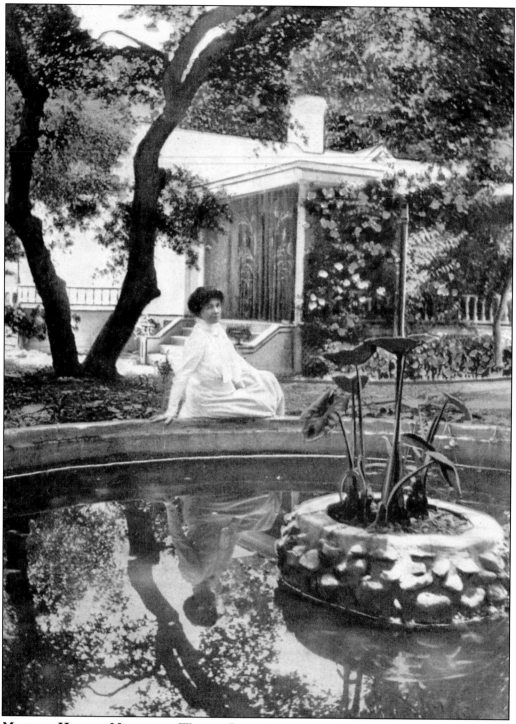

MADAME HELENA MODJESKA, WORLD-RENOWNED SHAKESPEAREAN ACTRESS. Madame Modjeska is shown here by the fountain at the home she named "The Forest of Arden," after Shakespeare's *As You Like It*. Located in Modjeska Canyon in the Santa Ana Mountains, it is now a historic park owned and managed by Orange County.

POSTCARD HISTORY SERIES

Orange County

Orange County Historical Society

ARCADIA
PUBLISHING

Copyright © 2005 by Orange County Historical Society
ISBN 978-0-7385-3054-3

Published by Arcadia Publishing
Charleston, South Carolina

Printed in the United States of America

Library of Congress Catalog Card Number: 2005930079

For all general information contact Arcadia Publishing at:
Telephone 843-853-2070
Fax 843-853-0044
E-mail sales@arcadiapublishing.com
For customer service and orders:
Toll-Free 1-888-313-2665

Visit us on the Internet at www.arcadiapublishing.com

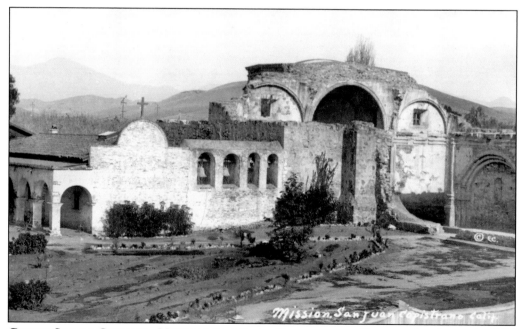

GREAT STONE CHURCH, MISSION SAN JUAN CAPISTRANO. Construction began in 1797 and took nine years. When completed, this cathedral-like church, cruciform in design, stood five stories high, was covered by seven domes, and could be seen from miles away. A massive earthquake on December 8, 1812, destroyed most of the structure. The sanctuary, shown here, was left virtually intact. The mission has since been rebuilt and a new church erected nearby, but the ruins of the Great Stone Church still stand as a reminder of California's early Spanish period. This image is an Edward Cochems photographic postcard.

CONTENTS

ACKNOWLEDGMENTS

The pictorial history of Orange County, as told through vintage postcards from the late 19th century through the mid-20th century, was compiled by the Orange County Historical Society under the direction of Betsy Vigus, editor of the society's newsletter, *County Courier*. Other members of the 2005–2006 board of directors contributing to the book's publication are Phil Chinn, Don Dobmeier, Harriet and J. J. Friis, Ken Leavens, Judy Moore, Jane Norgren, Greg Rankin, Carolyn Schoff, John Sorenson, Tracy Smith Falk, Diane Taylor, and Richard Vining.

The society's archives were supplemented by the following members and friends sharing their postcard collections: Ken Chinn, J. J. Friis, Jorice Maag, Rob Richardson, Francy Saunders, Elinor Schmidt, Richard Vining, and especially Don Dobmeier. Finally, without Tom Pulley's extraordinary collection of photographic postcards, this book would not have been possible.

The Orange County Archives made their resources available with valuable assistance from archivist Phil Brigandi and assistant archivist Chris Jepsen. Local historians Dr. William O. Hendricks, Jim Sleeper, and members of local historical societies in Orange County provided research assistance. Jaime Harrison provided an oral history and informative documents from early Sunset Beach developers. The following public libraries and their local history room personnel were very generous with their time and resources: Anaheim, Brea, Corona del Mar/Newport Beach, Dana Point, Fullerton, Laguna Beach, Santa Ana, and the private Sherman Library and Gardens in Corona del Mar.

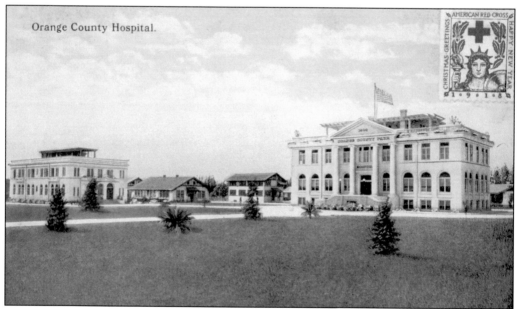

Orange County Hospital.

ORANGE COUNTY HOSPITAL AND FARM. On March 5, 1913, architect Frederick Eley's plans for a county hospital were adopted. On September 16, 1913, Chris McNeil was awarded the contract to build the hospital at a cost of about $46,000. In the fall of 1914, the hospital opened. The site included a medical facility and a poor farm (a home for the indigent and the senile). The original structure can still be seen, though partially obscured by the University of Irvine Medical Center, in the city of Orange.

INTRODUCTION

The Orange County Historical Society offers this postcard book as a broad look at a bygone era. This work covers, with a few exceptions, what can be referred to as the agricultural period of Orange County's history from its creation in 1889 until about 1955. It is not meant to be a comprehensive history of the county, but rather a collection of snapshots in time.

The U.S. Post Office first issued the simple "penny postcard" in 1873. The introduction of colored postcards at the Columbian Exposition in 1893 added color to a black-and-white world. Most postcards were mass-produced to support tourism to a particular site; however, some postcards were privately printed with family photographs and mailed to family and friends or retained as family history. In 1898, the postal service allowed privately published cards to be mailed at the same rate. Postcards were popular because they were inexpensive to mail, nice keepsakes of scenes worth remembering, and an easy way of communicating using a shorter and less formal writing style. The "golden age" of the postcard lasted until the 1920s.

When the state of California was admitted into the union in 1850, only three of the 27 counties covered all of Southern California (Santa Barbara, Los Angeles, and San Diego Counties). The first city in the area, Anaheim, was established in 1857, followed by Santa Ana and Orange in 1869–1870. But the first attempt by Orange County to secede from Los Angeles County didn't happen until 1870; several subsequent attempts failed. Finally, on August 1, 1889, the county was open for business, with Santa Ana as its county seat.

There were many factors that shaped the lifestyle of Orange County. Transportation, agriculture, industry, and recreation have played vital roles. Railroads served as the catalyst of economic development in the late 19th century, allowing mineral and agricultural wealth to be shipped to emerging markets. This also allowed access to places of leisure and recreation. The coming of the railroads facilitated the accumulation of wealth that attracted more people into the area and thus promoted further growth in the area.

The development of the railroads in Orange County followed the development of Orange County's major cities. The Southern Pacific Railroad arrived at Anaheim in January 1875 (nearly 20 years after Anaheim was established) and reached Santa Ana in December 1877. The Santa Fe Railroad reached Santa Ana in September 1887 and was extended to Anaheim in June 1888. Rail service between San Diego and Los Angeles was finally completed in August 1888. It replaced the previous stage service that required a 21-hour ride. For most of the southern half of the county, the old-fashioned horse and buggy or wagon was the prevailing mode of transportation until well into the early years of the 20th century.

Despite the county's name, oranges have not always been the primary agricultural crop in Orange County. Crops have varied over time and in different regions of the county. While the county was still part of Los Angeles County in the early 1880s, the region was touted as the third highest producer of wine in the state. In 1914, the most important crops were sugar beets, walnuts, apricots, celery, oranges, lemons, and lima beans. By 1940, major sources of income were from agriculture and petroleum. With the advent of the automobile, highways became more important, and agriculture in Orange County began to see a steady decline. The Highway Bond Act of 1912 brought the state highway network through Orange County by 1916. In 1929, Pacific Coast Highway was completed through Orange County. This joined the last link in the coast highway route, and vacationers began arriving in ever increasing numbers. Postcards were an inexpensive souvenir to send back home.

In spite of post–World War II attempts to anticipate increased population, early planning assumed that the county agricultural base would remain strong, especially in the southern part. The initial planning was adequate, but population projections were soon exceeded as

manufacturing opportunities boomed. This brought jobs, people, housing, and support facilities such as shopping centers—all displacing established agrarian areas. Even with the decline of the aerospace industry in the 1990s, the closing of area military bases, and the exodus of many manufacturing jobs, the Orange County economy has remained strong. As with agriculture, the manufacturing industry has waned as the dominant economic base and has been replaced by the service sector.

Recreation and tourism have long been key factors bringing travelers from all over the globe to marvel at natural wonders like the Orange County coastline, beaches, and the man-made destinations of Disneyland, Knott's Berry Farm, and other area resorts. Images of boating, fishing, and bygone local favorites like Lion Country Safari and the Japanese Village and Deer Park are indicative of the importance of Southern California leisure lifestyle for tourists and residents.

We hope you enjoy this historic and memorable journey into Orange County's past of images and scenes that once existed and perhaps still linger with nostalgia. Some images speak for themselves. Others have required more lengthy explanations. Each card has been carefully researched to obtain more details on the background information and historical period depicted. We welcome any additional information readers might be able to provide on the postcards contained in this volume. Please take a moment to remove yourself from the present and take a trip with us to explore Orange County history through the imagery of these vintage postcards.

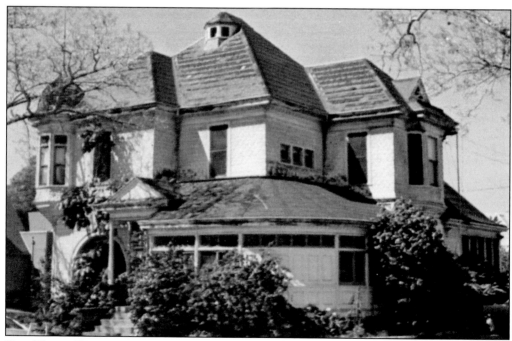

DR. HOWE-WAFFLE HOUSE AND MEDICAL MUSEUM, 1975. This Victorian-era home was built in 1889 (the year the county was formed) by Dr. Alvin J. Howe, former Santa Ana mayor, for his wife, Dr. Willella Howe, the most prominent female pioneer doctor in Orange County. Owned and maintained by the Santa Ana Historical Preservation Society, the Orange County Historical Society (OCHS) has an office in the building. This postcard is from a photograph taken before the move and restoration, by the late Allen W. Goddard, an OCHS member.

One

CENTRAL
ANAHEIM, ORANGE/EL MODENA, SANTA ANA, AND TUSTIN

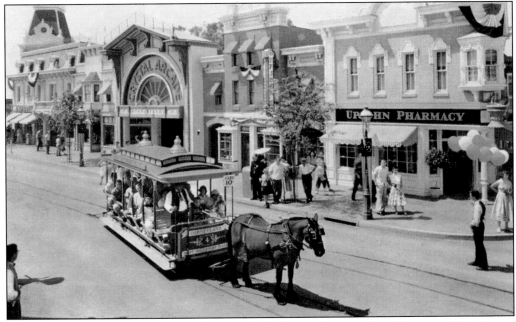

DISNEYLAND, 1955. This picture of Disneyland's horse-drawn trolley No. 4 on Main Street, U.S.A., was taken at a "dress rehearsal" before the park opened on July 17, 1955. This explains the small number of visitors on Main Street. The original streetcars, Nos. 1 through 4, have all remained in service. Each one-horse powered car is operated in the time-honored fashion with a two-member crew (one directs the horse and the other collects the fares). The mode of power has been difficult to maintain, requiring a stable of 16 horses kept in the park's backstage "Circle D Corral" to provide adequate horsepower. In 1956, motor driven "Omnibuses" were added.

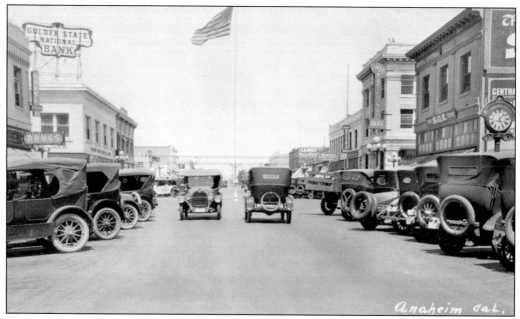

DOWNTOWN ANAHEIM, 1920s. This view is near the intersection of Los Angeles Street (Anaheim Boulevard) and Center Street (Lincoln Avenue). William E. Alexander (president of Union Brewing Company) presented Anaheim with the flagpole that was placed in the middle of the intersection in 1918. In 1924, it became a liability as a traffic hazard, because drivers kept running into it. The flagpole eventually had reflectors on it to warn drivers, but that was not successful. There was resistance to the flag from the local klavern of the Ku Klux Klan, who insisted it be removed. The flagpole was reinstalled on April 24, 1925, as a result of a petition submitted by citizens, with a golden eagle emblem added to the top.

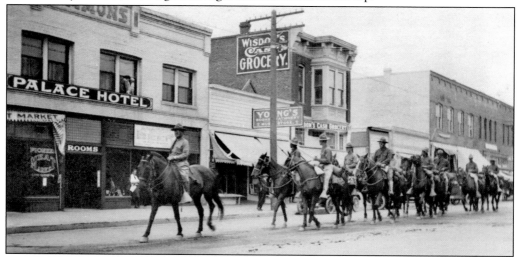

ANAHEIM NATIONAL GUARD ON PARADE. Anaheim's National Guard Unit Company E is parading down Center Street (Lincoln Avenue) in 1908. The Palace Hotel was upstairs and businesses were at street level. The Palace Meat Market (sign under Palace Hotel) was one of these. Wisdon's Cash Grocery (sign on the side of the building) was on the ground floor, with a residence or offices upstairs. The address of the old Palace Hotel was 119 East Center Street (Lincoln Avenue).

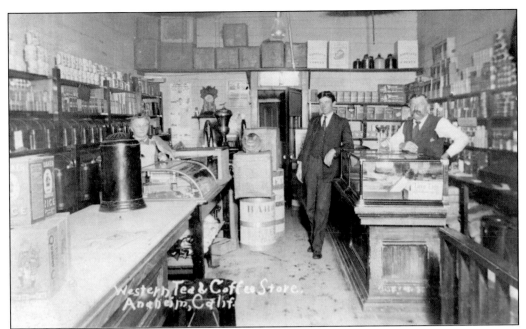

WESTERN TEA AND COFFEE STORE. This shop was located at 110 South Los Angeles Street (Anaheim Boulevard), with C. K. Marshall as proprietor. This business was listed only once in the 1911 city directory. It is possible that tea and coffee were not the beverages of choice—many wine shops were also listed in the directory.

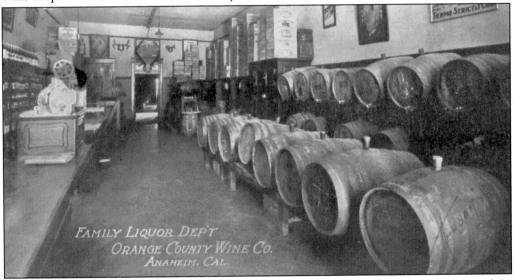

ORANGE COUNTY WINE COMPANY. Pictured in 1914 is the family liquor department of the Orange County Wine Company. The owners, listed in the 1913 city directory, were Nicolas, Erwin, and Bayha. The 1916 city directory listed only Pierre Nicolas as the owner. The building was at 133 West Center Street (Lincoln Avenue). According to the directory, there was another wine shop across the street at 134 West Center Street. It was not clear if the shops bought wine in barrels, or if they processed grapes purchased from other areas. The original grapevines were destroyed in 1885 by the disease eventually known as Pierce's Disease, a bacterium spread by certain types of leafhoppers known as sharpshooters.

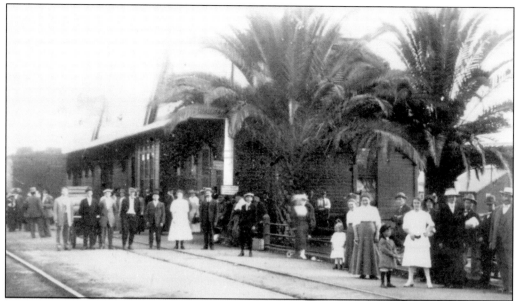

ANAHEIM SANTA FE DEPOT, C. 1900. The original Santa Fe Depot in Anaheim was built in 1888, and located at 708 East Center Street (Lincoln Avenue). The station was torn down in 1940 and rebuilt in the same location. This second station building was demolished in the 1980s as part of the Anaheim Downtown Redevelopment Plan.

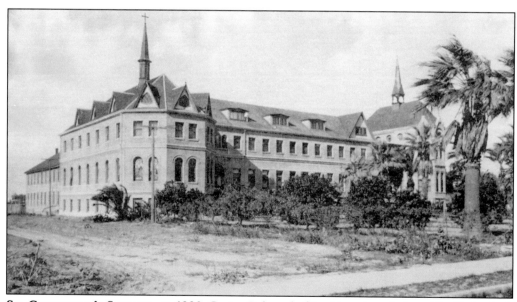

ST. CATHERINE'S SCHOOL, C. 1920. Gustav Behrend of San Francisco designed St. Catherine's Orphanage, later St. Catherine's Military School. Built in 1889, it was located at 215 North Palm Street (Harbor Boulevard) on the west side of the street. The dirt road on the left side of the building is Chartres Street. Sidewalks were cement, but many roads were still unpaved. The school continues in operation today, with a new facade and administration offices completed in 1953. The campus area was extended to eight-and-a-half acres after the movie *The Private War of Major Benson*, starring Charlton Heston and Julie Adams, was filmed there in 1955.

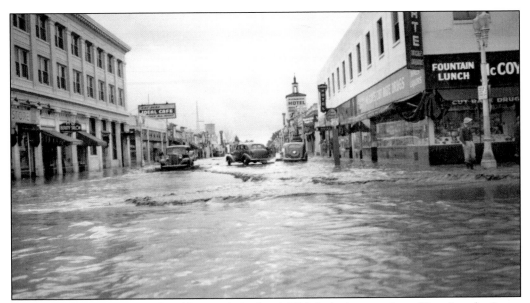

FLOOD OF 1938. The 1938 flood hit Anaheim hard. This is the intersection of Los Angeles Street (Anaheim Boulevard) and Center Street (Lincoln Avenue), looking south down Los Angeles Street. The spire seen on the right in the distance is the Pickwick Hotel. On some of the other streets, residents traveled by rowboat to higher ground. The Pickwick Hotel was a landmark and tried to endure through the downtown renewal. In 1990, it was ultimately a victim of downtown redevelopment.

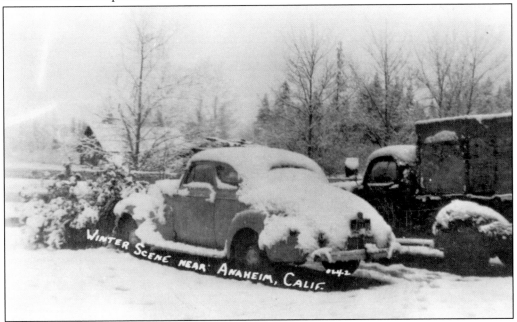

SNOWFALL! Yes, it snowed in Anaheim, California, on January 10 and 11, 1949, for the first time in about 16 years. The snowfall stretched from Buena Park to Santa Ana Canyon and from Carbon Canyon to the orange groves in Tustin and El Toro. Local responses included closing the schools and lighting smudge pots to save the oranges from freezing. It was an opportunity for many children to play in snow for the first time.

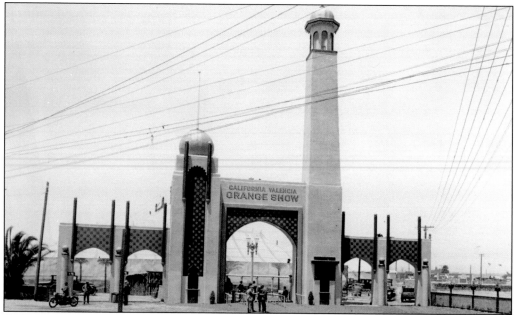

CALIFORNIA VALENCIA ORANGE SHOW. Starting in 1921, the orange show was held for a week each May until the Depression forced its closure in 1931. This 1925 photograph shows the entrance, touted as a "Permanent Entrance in the Moorish style." The 85-foot-tall tower's searchlights could "illumine the whole countryside." La Palma Park occupies the site today.

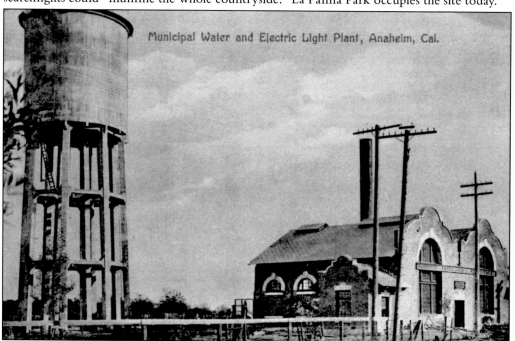

Municipal Water and Electric Light Plant, Anaheim, Cal.

MUNICIPAL POWER HOUSE AND CONCRETE WATER TOWER, 1908. Vard Hannum, who would become Anaheim's superintendent of the Light and Power Works, retiring from city service after 38 years, wrote the back of this card. A west Anaheim electric facility is named for him. This card had been mailed to Michigan and yet found its way back to Anaheim and Steve Faessel, Anaheim Utility historian, who had researched Vard's career in Anaheim.

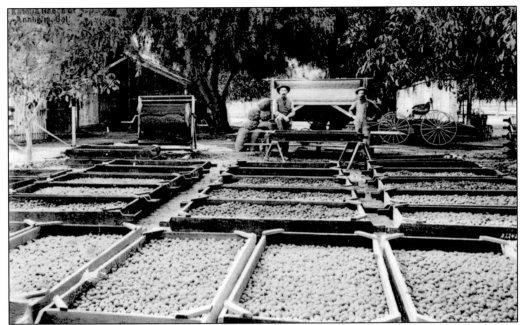

WALNUT DRYING ON KATELLA RANCH. In 1896, John Rea purchased 120 acres of land west of Anaheim. His walnuts are drying in the sun before being sent to the packinghouses; each had to be turned daily. Walnuts were grown throughout the county. At first, walnut groves were dry-farmed and were relatively pest free. Later irrigation was necessary and several pests became such a problem that many farmers turned to more lucrative crops.

BACKSIDE OF CARD ABOVE. John Rea sent this card to a relative in San Diego, showing how walnut drying was done on his Katella ranch—named for his two daughters, Kate and Ella. The ranch is long gone, but the name Katella lives on as a major thoroughfare in Orange County, continuing in Long Beach as Willow Street.

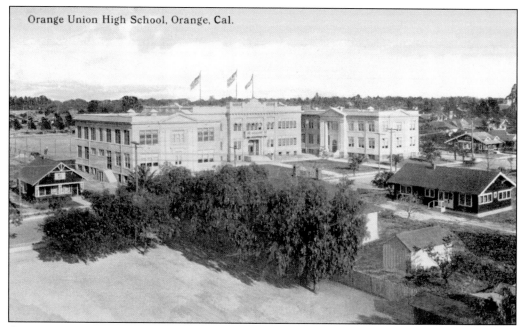

Orange Union High School, Orange, Cal.

ORANGE UNION HIGH SCHOOL, C. 1915. The Orange Unified School District, formed in 1903, completed its first building (see flags flying) in 1905 at the northeast corner of Glassell and Palm Streets. Facing west on Glassell Street, it was constructed on property purchased from Mrs. C. C. Honey for $2,500. Added to the campus in 1913 and creating a "U" were "The Twins," the commercial building (facing south) and the science building (facing north).

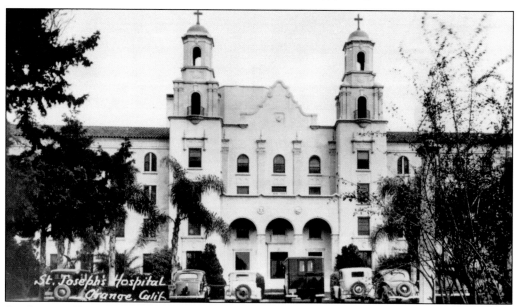

ST. JOSEPH HOSPITAL. Opened in 1929, St. Joseph Hospital was founded by the Sisters of St. Joseph, an order of nuns who came to Orange County in 1922. The hospital was expanded in 1964 and again in 1976. Another expansion and remodeling of the St. Joseph campus is currently (2005) underway which will restore the original Stewart Drive approach shown in this photograph from 1937.

16

ORANGE PLAZA AT NIGHT IN CHRISTMAS LIGHTS. Laid out in 1871 by Capt. William T. Glassell as part of the original plan of Richland, the public plaza was and has remained the center of Orange. This scene, photographed in 1937, views the plaza from East Chapman Avenue. The plaza is decorated for the Christmas holidays, a tradition of many years.

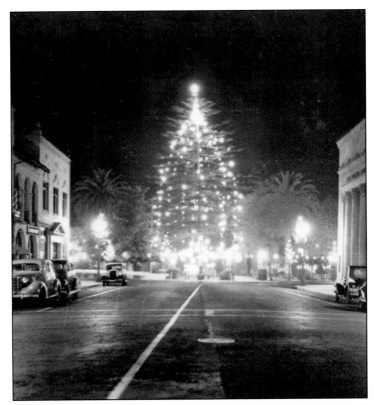

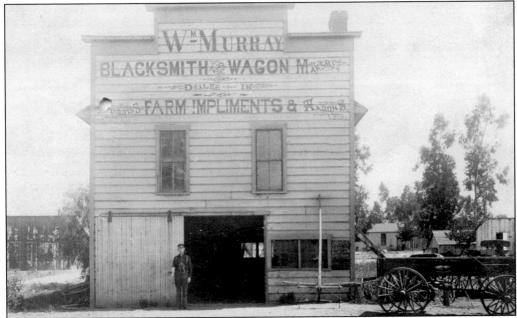

BLACKSMITH SHOP IN EL MODENA. William Murray, blacksmith, was practicing his craft as early as 1889 in the community of El Modena, east of Orange. According to county records, the business, located at the corner of East Chapman Avenue and Earlham Street, continued until 1938, although Murray died in 1918.

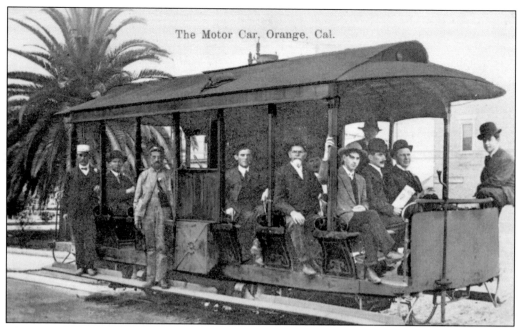

The Motor Car, Orange, Cal.

MOTOR CAR ON THE TRACKS. Horse-drawn streetcar service between Orange and Santa Ana began in 1888, but was replaced in 1896 by a steam-powered car built by the Tolle Brothers, operators of the line. Because of its shrill steam whistle, the locals called it the "Orange Dummy" or the "Peanut Roaster." This view, with one of the Tolle Brothers as the conductor, was photographed at Orange Plaza. The trolley continued on South Glassell Street to Santa Ana. (The tracks were relocated to Lemon Street after the new station was built in 1918.)

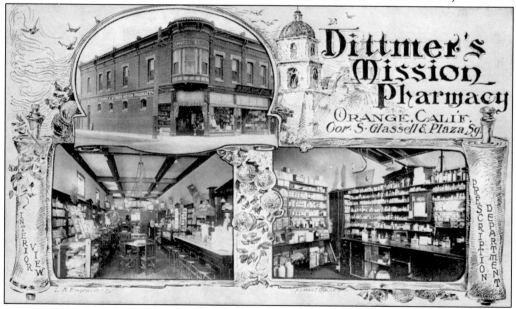

ADVERTISEMENT FOR DITTMER'S MISSION PHARMACY. Dittmer's Mission Pharmacy was first established at 131 South Glassell Street in 1905. In 1909, the pharmacy moved into the Willits Building (Campbell Block) at 101 South Glassell, occupying the space vacated by the Ehlen and Grote Grocery.

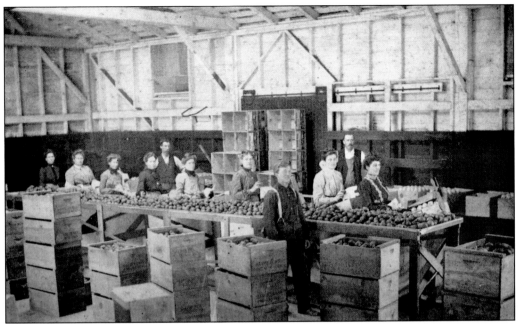

HEWES PACKINGHOUSE, C. 1905. This was the interior of the David Hewes packinghouse. The building, constructed in 1890, was located on the southwest corner of La Veta Avenue and Esplanade Street, south of El Modena. On the evening of January 13, 1947, it was destroyed by a spectacular fire, witnessed by hundreds of people.

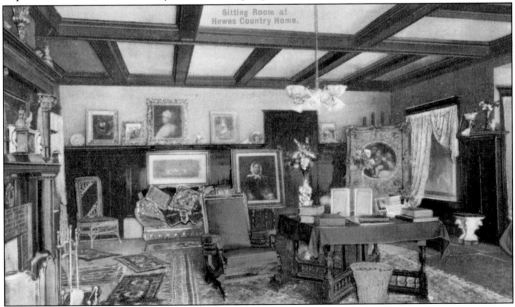

SITTING ROOM AT HEWES COUNTRY HOME. David Hewes (1822–1915) was a capitalist, philanthropist, and land developer. Around 1885, Hewes purchased approximately 820 acres near El Modena and built a home he named Anapauma. The term is not of Spanish origin as popularly thought, but is from the ancient Greek *anapauo*, meaning "resting place." The home was built for his wife, Matilda Gray Hewes, whose tenure in the home was unfortunately brief. She passed away on January 3, 1887.

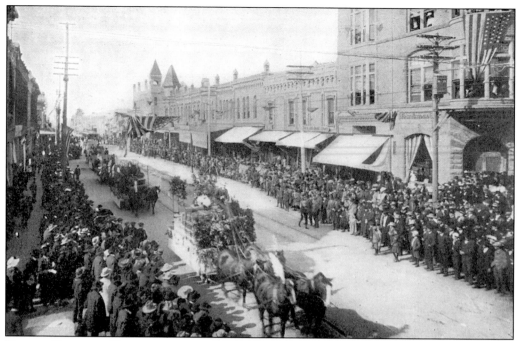

PACIFIC ELECTRIC RAILWAY. In November 1905, mass transit arrived in Santa Ana. The above photograph shows the celebration following the opening of the Pacific Electric Railway on Fourth Street.

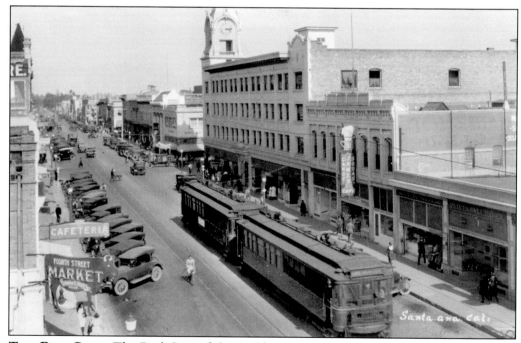

THE RED CARS. The Red Cars of the Pacific Electric Railway Company benefited the commercial life of every city on the rail line. This 1920 postcard shows a bustling downtown Santa Ana looking east on Fourth Street. The Spurgeon Building, crowned by a clock tower, can be seen in the center of this photograph.

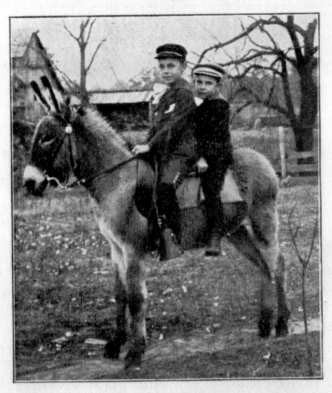

L. C. Co. 70—HAPPY DAYS.

I have reserved for you a fine Souvenir
for the Holidays. Call any time
during December and bring
this card with you

LOUIS PETERSEN

SCIENTIFIC HORSESHOER

409 Spurgeon Street. SANTA ANA, CAL.

EARLY ADVERTISEMENT FOR A SANTA ANA TRADESMAN. An advertisement created by Louis Peterson in 1905, seems to imply that if the bearer brought this card with him, a free picture would be taken of his children on top of a donkey during the holidays. Peterson promoted himself as a "scientific horseshoer." The use of postcards was very common for advertisements throughout the United States at this time.

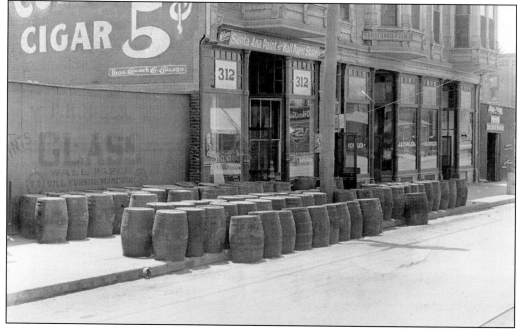

SANTA ANA PAINT AND WALLPAPER COMPANY. Owned by F. H. McElree, the Santa Ana Paint and Wallpaper Company was located at 312 West Fourth Street. This 1912 photograph shows barrels in front of the business, which, one would presume, contained paint.

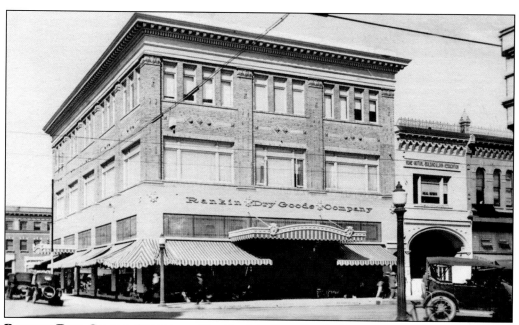

RANKIN DRY GOODS COMPANY. The Rankin Dry Goods Company was founded in Santa Ana on February 6, 1907, with J. H. Rankin as president. After his son Herbert Rankin became general manager, the store experienced an expansion that included a new building, constructed in 1917 at Fourth and Sycamore Streets at a cost of $60,000.

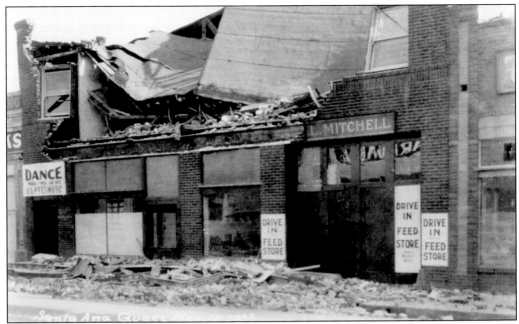

AFTERMATH OF THE 1933 LONG BEACH EARTHQUAKE. Not only were important buildings such as the county courthouse and Santa Ana Polytechnic High School damaged, but so were businesses like the Fred Mitchell and Son Drive-in Feed Store and the Rainbow Danceland. Both were located in the same building on East Third Street.

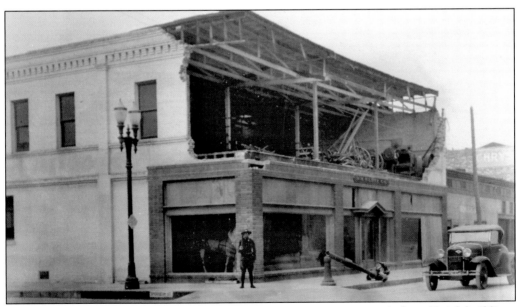

DAYS FOLLOWING THE 1933 EARTHQUAKE. In Santa Ana, many unreinforced brick buildings lost part or all of their facades. Following the evening earthquake, the American Legion was called out immediately. Shortly thereafter, National Guard companies from Santa Ana, Anaheim, Orange, and San Bernardino reported for duty, relieving the American Legion. Shown in this postcard, days after the earthquake, the debris has been cleared away and a guardsman is on duty, in uniform and armed.

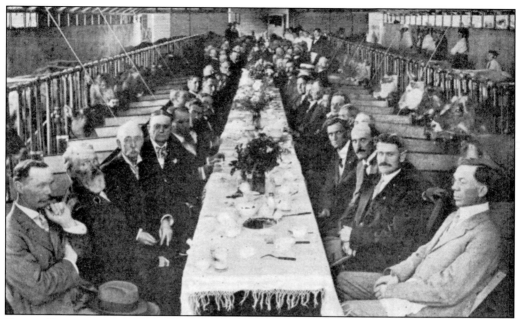

RAITT SANITARY DAIRY. James T. Raitt started his Raitt Sanitary Dairy in 1890 with seven cows. To prove just how sanitary his dairy was, a banquet was held in 1910 (with cows in attendance) in one of the ranch barns located at 1100 South Bristol Street. The famous singer and actor, the late John Raitt, was James's grandson. John Raitt's daughter, singer Bonnie Raitt, is James's great-granddaughter.

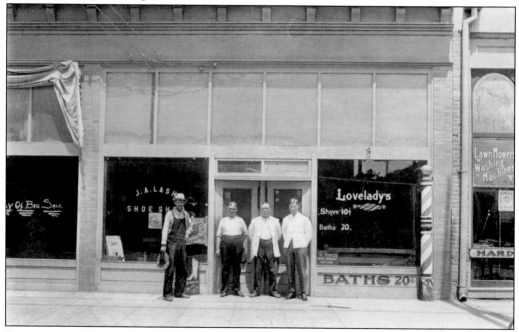

DOWNTOWN SANTA ANA. This photograph shows the diversity of businesses in downtown Santa Ana in 1912. An individual could take a bath for 20¢, have a shave at Lovelady's for 10¢, and buy a new pair of shoes at the James A. Lash Shoe Shop—all in the same building at 311 West Fourth Street and 311½ West Fourth Street.

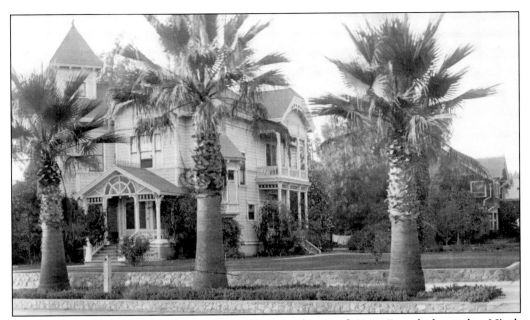

THE FRENCH HOUSE. The Queen Anne Victorian home of C. E. French, located at Ninth and French Streets in French Park, was one of the most magnificent homes in Orange County. Built in 1888, the house occupied half a city block. The house was torn down in the 1960s to make way for a Buffum's Department Store parking lot.

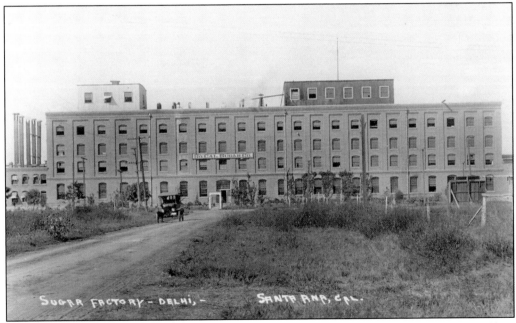

SOUTHERN CALIFORNIA SUGAR BEET FACTORY. This factory was one of five sugar milling plants in Orange County and was located at 2516 South Main Street, south of Delhi (now Warner Avenue) in an area that was then called Delhi. The founding officers of 1908 included James Irvine, James McFadden, and A. J. Crookshank.

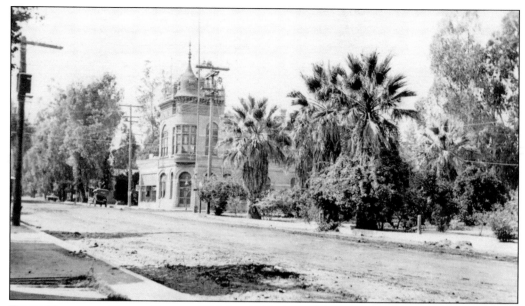

FIRST NATIONAL BANK, TUSTIN. This is a 1915 view of the First National Bank looking west on Main Street near the end of "E" Street, now Prospect Avenue. After the 1933 earthquake, the turret and gingerbread trim were removed to comply with new building codes. First Western Bank purchased the building in 1959 and it was razed sometime in the 1960s. Charles Edward Utt was president of the bank. He owned the Tustin Water Works, established the Utt Juice Company, was director and treasurer of the Haven Seed Company in Santa Ana, and president of the San Joaquin Fruit Company.

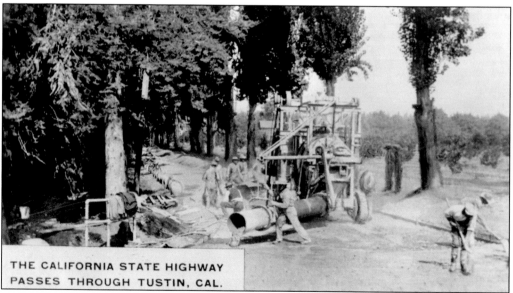

THE CALIFORNIA STATE HIGHWAY PASSES THROUGH TUSTIN, CAL.

GOOD ROADS PROGRAM, 1915. An early style mobile cement mixer is pouring cement for a state highway (El Camino Real) through Tustin, under the Good Roads program in 1915. This mobile mixer system led to the development of trucks able to carry premixed, ready-to-pour concrete (Ready-Mix trucks) for deliveries to job sites.

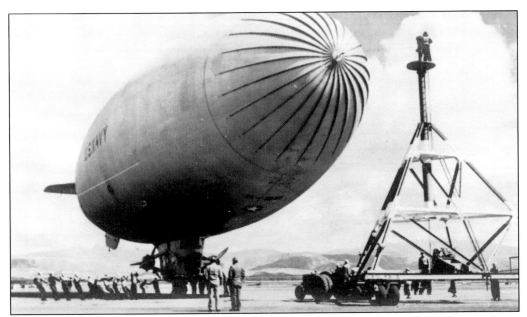

TUSTIN AIR BASE. A U.S. Navy airship at the Lighter-Than-Air Base is being attached to a mobile mooring tower. Note the "high-tech" power unit bringing the mooring tower closer to the airship. The airships were stored in two wooden hangers, 1,088 feet in length—each greater in length than three football fields. One of the hangers appears on the postcard below. The airships were used for coastal surveillance during World War II. The correct military term for the airship was Airship, Type B, Limp. It is easy to see how they became known as "blimps."

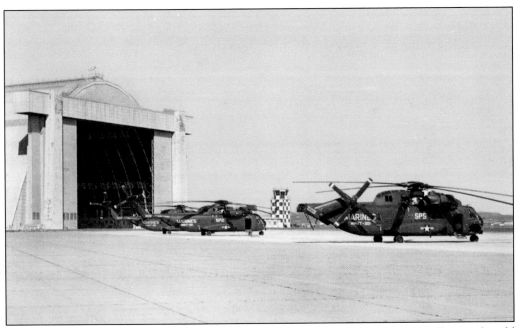

MARINE CORPS AIR FACILITY. This scene shows the Marine Corps Air Facility at the old Navy Lighter-than-Air Station on Red Hill Avenue. The CH-53 Sea Stallions were assigned to the facility to train helicopter squadrons for duty in South Vietnam.

SHERMAN STEVENS HOME. In 1887, Sherman Stevens built this Queen Anne Victorian house at 228 West Main Street. The house was constructed of redwood lumber shipped from Eureka, California, to McFadden's Landing in Newport Beach. The gardens surrounding the house covered an entire city block. Exotic plants like azaleas, rhododendrons, tuberous begonias, cacti, and palms created a tropical setting. The garden also included a large aviary with canaries, finches, and other colorful birds purchased in Capetown, Rio de Janeiro, Calcutta, and Singapore. For many years, the aviary was open to the public and to school children for field trips.

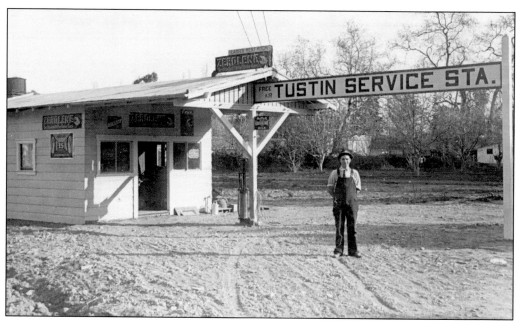

TUSTIN SERVICE STATION. The Tustin Service Station featuring Zerolene gasoline was identified in a 1922 Orange County directory as owned by Richard McCarthy and Marcy Burgess. The station was located at First and D Streets where El Camino Real took a 90-degree turn through Tustin. The message on the reverse side reads, "This is Gavin at the service station. Yes I painted the big sign, Some class—yours G. H. B."

CRAFTSMAN HOUSES ON MAIN STREET. The house in the foreground was built in 1914 at 400 West Main Street for Waldo and Jessie Liehy. The house design reveals its oriental influence and includes a wraparound porch on the far side covered by roof gables. The house features leaded glass panels around all street-facing windows, with beveled windows in the front door and leaded glass sidelight doors on each side of that door. Henry Boosey purchased the house in 1946 and his son Lecil sold the house to Richard and Sally Vining in 1969.

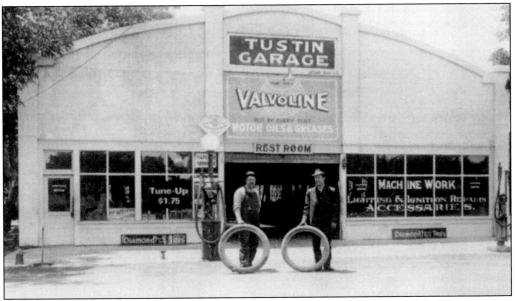

TUSTIN GARAGE. The Tustin Garage located at 560 El Camino Real was built in 1915 for Will Huntley and Nick Gulick. Gulick is on the left and Huntley is on the right. Note the 1915 price for a tune-up in the storefront window. The building remains in use as a garage today.

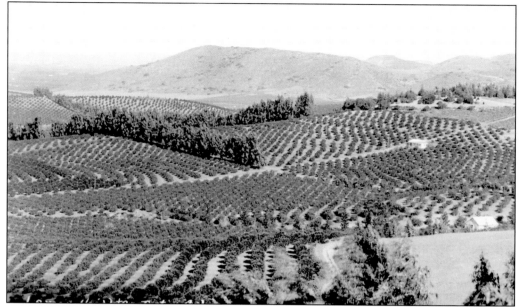

LEMON HEIGHTS RANCH. This view of citrus and avocado groves shows the hills of North Tustin in the foreground. The curved road around the groves is Crawford Canyon Road. In 1910, C. E. Utt and Sherman Stevens developed Lemon Heights Ranch on Irvine Ranch land. Sherman Stevens, along with C. E. Utt and James Irvine, were founding partners in the San Joaquin Fruit Development Company in 1908 on 1,000 acres.

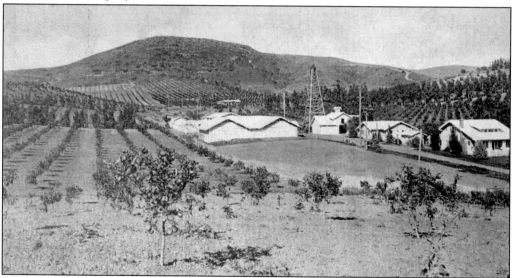

1,300-ACRE MARCY RANCH. This postcard of George Marcy Ranch was sent to Green Field, New Hampshire, in 1921. Because of its configuration, the ranch was commonly called *The Maltese Cross Ranch* and in its heyday, contained more than 1,300 acres. Primarily a citrus ranch, it also included groves of avocado, persimmons, and walnuts. An interesting minor crop was bird of paradise blooms that were shipped to Chicago and New York, where the blooms were sold at prices ranging from 75¢ to $1.25 each. In 1944, five years after George Marcy's death, 750 acres of ranch were sold to Walter Cowan for $250,000. The final part of the ranch was sold in 1950 for $275,000, ending 39 years of agricultural use under the Marcy name.

Two

NORTH
BREA/CARBON CANYON, FULLERTON, LA HABRA, PLACENTIA, AND YORBA LINDA

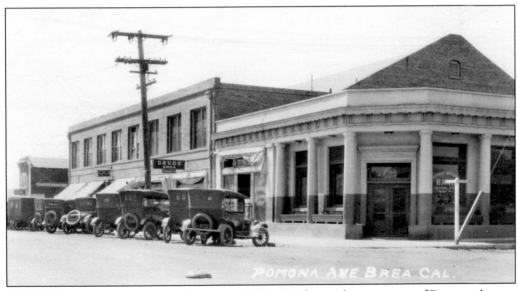

LOOKING SOUTH ON POMONA AVENUE, 1920S. On the southwest corner of Pomona Avenue (Brea Boulevard) at Ash is the La Habra Valley Bank. In 1915, Jay C. Sexton bought controlling interest in the bank. An ardent supporter of cityhood for Brea, he became Brea's first mayor in 1917. In 1926, the bank became the First National Bank with attorney Albert Launer's offices in the back. The bank has also served as Brea's often-moved post office. The last owners of the building were the Lavold family, owners of That Frame Place. The adjacent Sewell Building offered commercial space to Peterkin's Meat Market and a Rexall Drug Store, while the upstairs provided space for early city government meetings. The freestanding building to the south was the home of the much loved Brea Bakery. The building spent its last days as a bar, Sam's Place. A city renewal project begun in the 1970s has removed most of Brea's old town.

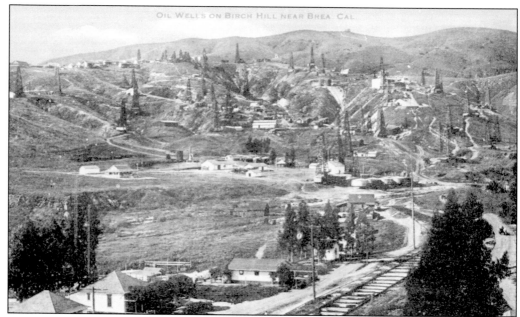

BIRCH HILL. In 1911, A. Otis Birch of the Birch Oil Company brought in "a big one" with well No. 5 on a hill behind Brea. Birch Hills natural gas was converted on the spot to "casinghead gasoline." The extreme volatility of this product required specially prepared tanks for shipment. This casinghead gasoline was used primarily to blend with engine distillates to increase fuel output for cars. By the 1930s, the field's production was running at 4,000 gallons a day.

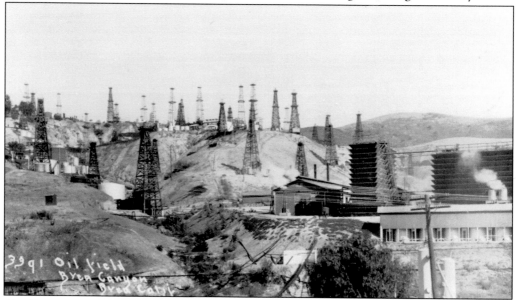

OIL FIELDS AND COOLING TOWERS. Brea Canyon's oil production was still going strong in the 1930s. Drilling on hilly sites was a problem. Wells had to be placed on the ridges and not in the more sheltered canyons where they might be flooded by winter storms. The once sage- and oak-covered hills were now forested by the latest in oil derricks. In this scene, cooling towers below the canyon begin the processing of products, which will be transported from Brea by tanker trucks or pipelines to refineries as far away as El Segundo.

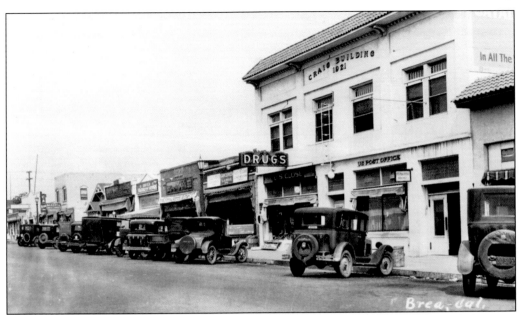

CRAIG BUILDING. This imposing structure on the east side of Pomona (Brea Boulevard), between Birch and Ash, was built in 1921 by Isaac Craig and his son Ted Craig (1896–1979). The solid two-story building in Brea's commercial area housed many businesses, including a pharmacy and the post office on the main floor, with banquets and civic meetings held in the auditorium on the floor above. Brea was a newly incorporated town made profitable by a booming oil industry and successful agriculture. Ted Craig would soon turn to a life in civic and state government. As Brea's most famous citizen, he well earned the title of Mr. Brea Olinda.

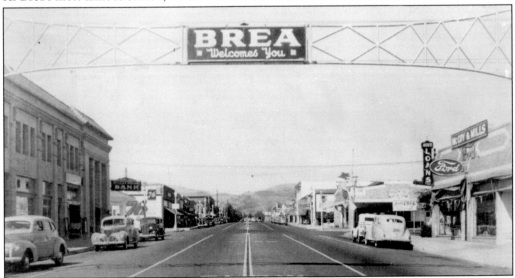

BREA WELCOME SIGN. Shown here in a 1940s street scene, the Brea welcome sign stretched across Brea Boulevard near Birch for decades. Looking north, the McCoy and Mills Ford Agency figures dominately on the east side of the street, while the Oilfields National Bank sits on the west side. Carefully preserved during Brea's downtown renovation, the sign is displayed today in the plaza outside the Edwards Theatre complex, reminding us of Brea's energetic, small-town past.

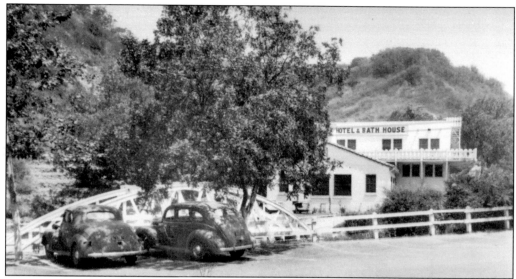

LA VIDA MINERAL HOT SPRINGS. La Vida Mineral Hot Springs was located in Carbon Canyon, just east of Brea and north of the former Olinda Oil Field. Appreciated first by the American Indians, the Spaniards, and then the Mexican settlers, it became a public bathing spa for the early oil field workers. In 1921, the paving of the Carbon Canyon Road put La Vida on the map. It became a popular cafe, hotel, and health resort. Its remote location attracted Prohibition bootleggers, who used the nearby surrounding narrow canyons to carry on their illegal business. In the early 1920s, the La Vida Bottle works was formed to sell a bright green lemon–lime soft drink. The hotel finally burned and the property was sold. The cafe, under separate management, became a famous biker bar. Upon the death of the manager, however, the business was closed and building underwent demolition.

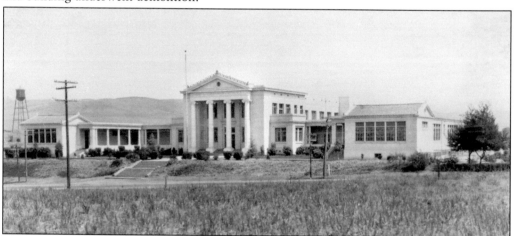

GRAMMAR SCHOOL. The Brea Grammar School was erected on the corner of Pomona and Deodara, now Brea Boulevard and Lambert, in 1916 at the north end of Brea. With its white columns and Greek façade, it was an architectural showpiece proudly stating Brea's interest in public education. Brea had passed a $60,000 bond issue to build the school, which housed grades one through eight. Some of its 275 students had to travel long distances from their homes in the surrounding oil fields to attend. The 1933 earthquake damaged the building and it required some modifications of its unique design. Today it proudly serves the community as Brea Junior High School.

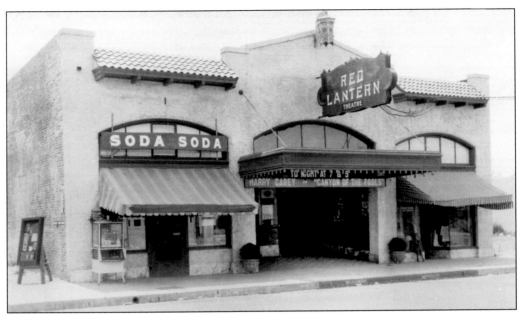

RED LANTERN THEATRE. March 7, 1922, marked the opening of the Red Lantern Theatre on what is now Brea Boulevard. Opening night movie patrons were awed by the theatre's rich Oriental interior theme, which preceded the Hollywood Chinese Theatre's design by several years. Patrons were treated to a Municipal Band performance, a pipe organ recital by Robert Morgan, and a viewing of the silent film *A Game Chicken,* starring Bebe Daniels. The theatre served Brea's movie needs for many decades. Its final years were spent as a church before it was demolished as part of Brea's urban renewal project.

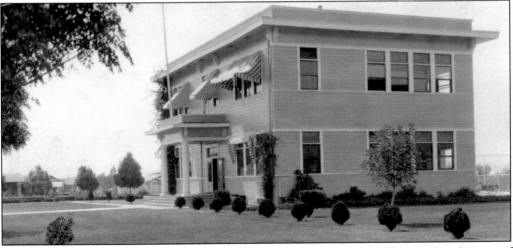

UNION OIL BUILDING. Before there was a Brea, there was the small agricultural town of Randolph named after the Pacific Electric Railroad's general manager, Epes Randolph. In 1910, the Randolph School District constructed this two-story building containing four classrooms of grades one through eight at a cost of less than $5,000. It soon became overcrowded, and the Union Oil Company, ever anxious to keep its workers' families happy, agreed to swap the building for land over on what is now Brea Boulevard and Lambert. The building became a Union Oil Company headquarters, and the new site was used for the construction of what is now Brea Junior High School.

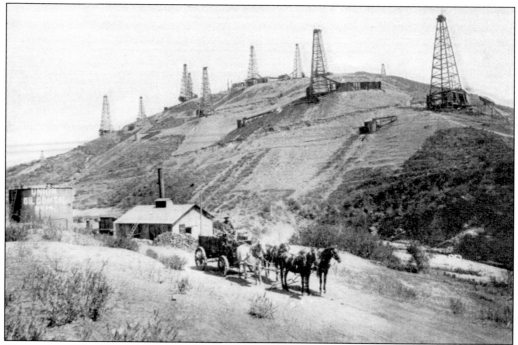

UNION OIL COMPANY WELLS. In post–Civil War Southern California, the search for petroleum was on. It was hoped that petroleum, instead of coal, would power the nation's expanding railroads. By the early 20th century, Brea Canyon, located in the Puente Hills of Orange County, was home to numerous small oil drilling companies attempting to bring in oil wells, often with great success. By 1900, Union Oil Company had extracted a half million barrels of oil from the Brea Stearns Lease. The town of Brea and a paved Brea Canyon road to the Pomona Valley were yet to come.

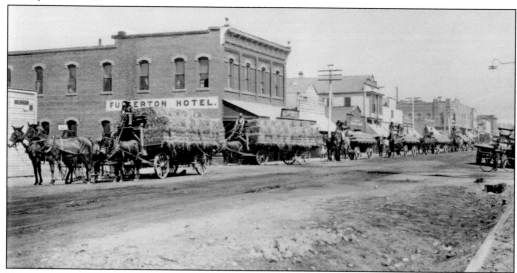

FULLERTON HOTEL. The Fullerton Hotel was located on the corner of Santa Fe Avenue and Spadra Road (Harbor Boulevard). Built in 1890 for the sum of $8,000, the hotel benefited from being near the Santa Fe Railroad depot. Several horse-drawn wagons are carrying hay and grain southward on Spadra Road. In 1923, the hotel was demolished.

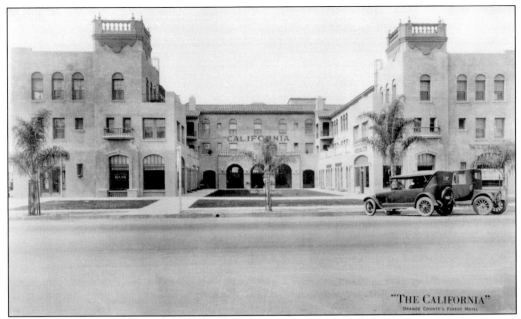

CALIFORNIA HOTEL (VILLA DEL SOL). Erected in 1922 on the site of a former comfort station at the corner of Spadra Road (Harbor Boulevard) and Wilshire Boulevard, this hotel boasted 22 apartments and 55 single rooms, plus space for commercial business. It was built with funds raised by public stock subscription. Charles Chapman, Fullerton's first mayor, led the campaign to build the hotel with a pledge of $25,000. Today the building houses popular shops and restaurants.

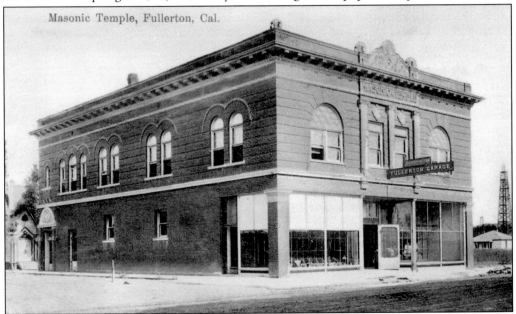

MASONIC TEMPLE, FULLERTON. Constructed in 1901 at 201 Spadra Road (Harbor Boulevard), this was the first home of the Masonic Order. Notice the oil-well derrick on the right, located in downtown Fullerton. In 1919, the Masons moved to a larger building located at Spadra Road and Chapman Avenue. The original temple is now called the Parker Building and is named after the family who has owned it for over 80 years.

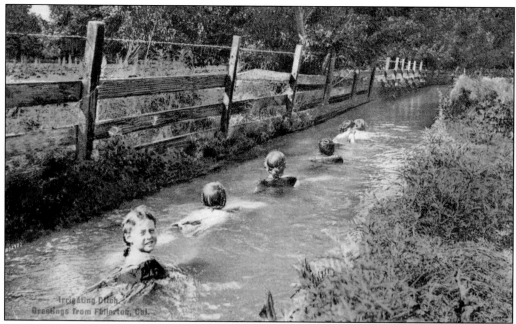

HOT DAYS, FUN IN THE WATER. A happy group of Fullerton children are cooling off in an irrigation ditch used to bring water to a local citrus ranch.

FULLERTON UNION HIGH SCHOOL, C. 1903. This was the second home of Fullerton Union High School and was the school's first permanent building, located at Wilshire Boulevard and Lawrence. The school was founded in 1893, with classes held in a rented room on the second floor of the Fullerton elementary school building. The five rigs shown conveyed students for free from Placentia, Olinda, Randolph, La Habra, Orangethorpe, and Buena Park.

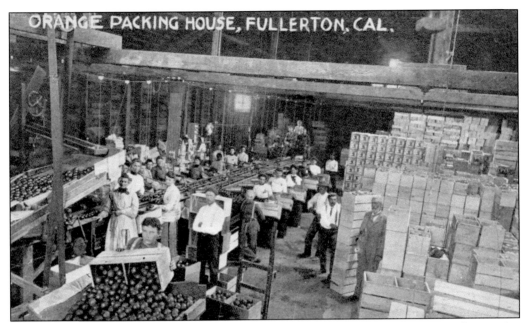

ORANGE PACKINGHOUSE IN FULLERTON, 1912. This unidentified view shows the interior of a typical orange packinghouse with male and female employees. In 1912, there were eight citrus packing establishments in Fullerton, the largest being Bentley Fruit Company, Charles C. Chapman, and the Placentia Orange Growers Association. Citrus became the leading economic support upon which the city grew into the 20th century.

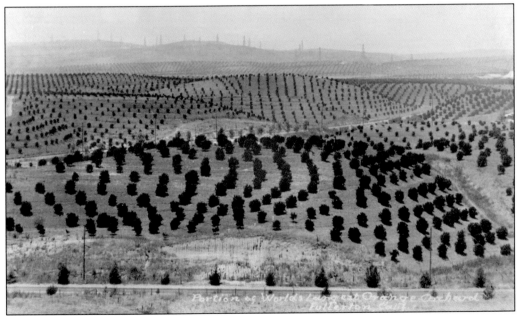

THE BASTANCHURY RANCH. This ranch billed itself as the "World's Largest Orange Orchard." Here is a view, *c.* 1920, looking northward toward the oil well-laden hills above the city of La Habra. The Bastanchury family of Basque heritage farmed this property until the Depression of the 1930s.

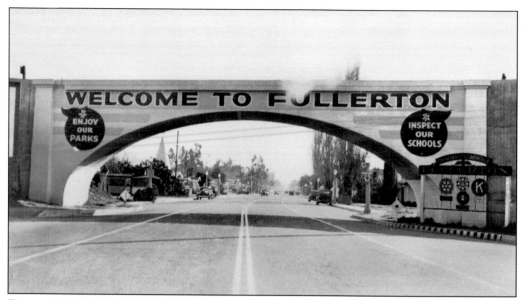

PACIFIC ELECTRIC BRIDGE. The Pacific Electric Railway Viaduct (Red Cars) was built in 1917 over Spadra Road (Harbor Boulevard). This sign became Fullerton's signature welcome mat until it was demolished in 1964.

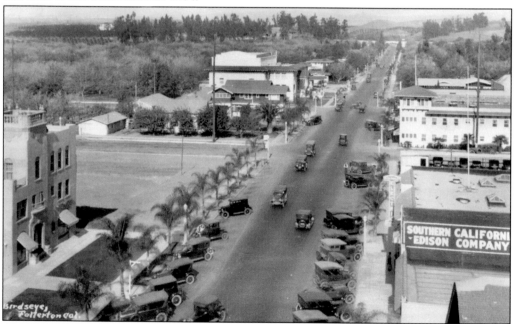

DOWNTOWN FULLERTON. Looking north on Spadra Road (Harbor Boulevard) about 1922, the large white building in the upper left corner is the second home of the Masonic Temple, built in 1919. Notice that there is no sign of the Fox Theater, which opened in 1925, across the street from the Temple. An empty lot shown north of the then recently completed California Hotel (now the Villa Del Sol) was originally slated to become the site of Fullerton's new city hall. The Farmers and Merchants Bank is now at that location. The large wooden building with the tower pictured on the right side of the postcard was the home of the Marwood Apartments located at Spadra Road and Whiting Avenue. The building no longer exists.

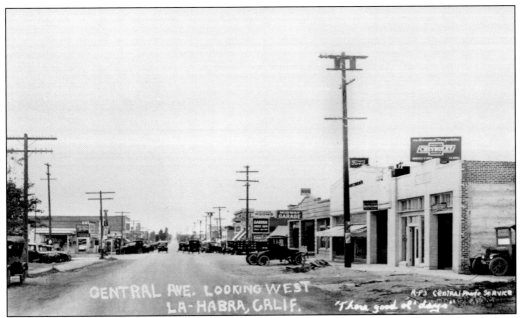

BUSTLING LA HABRA STREET. A view of East Central Avenue showing the J. H. Roberts Chevrolet dealership and the Midway Garage owned by Frank Reinolds and J. E. McGrath. Both businesses were located near the corner of Central Avenue (La Habra Boulevard) and Main Street. Many of the streets of La Habra, including Central Avenue, were named by members of the La Habra's Women's Club, founded in 1898.

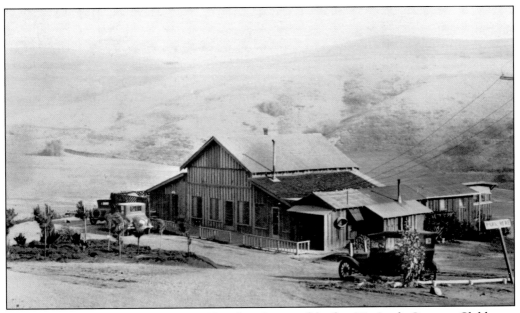

HACIENDA COUNTRY CLUBHOUSE. Here is an image of the first Hacienda Country Clubhouse built in 1921 by the Los Angeles developer of La Habra Heights, Edwin G. Hart. His promotional brochures read, "La Habra Heights, only 45 minutes from 7th and Broadway." A more lavish Spanish-style clubhouse was built in 1925 at a cost of $4,000.

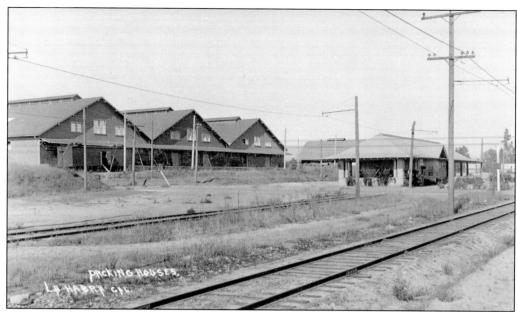

LA HABRA CITRUS ASSOCIATION, 1913. The La Habra Citrus Association, formed in 1911, became a member of the California Fruit Growers Exchange in 1917 and sold citrus using the famous Sunkist label. The packinghouses were built in 1913 bordered by Second Street on the north and Hiatt Street (Euclid) on the west. The La Habra Pacific Electric Depot, built in 1909, is shown to the south of the packinghouses. In the mid-1970s, the depot was moved across the street to Portola Park and now serves as a community theatre.

LOCAL LUMBER COMPANY. In 1907, two Fullerton businessmen purchased two acres at the corner of Cypress and Central Avenue in La Habra. This 1915 photograph shows the partners standing in front of the Brown and Dauser Lumber Company.

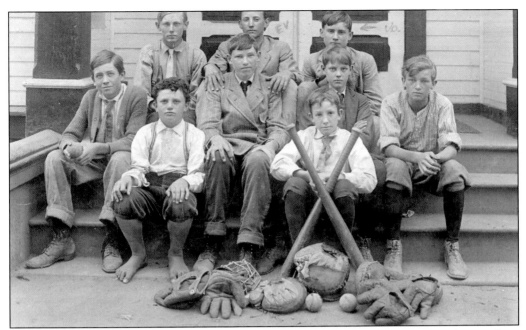

LA HABRA GRAMMAR SCHOOL BASEBALL TEAM, 1912. The year this photograph was taken, baseball was an important national game. The boys on this baseball team dressed up and posed for their photograph. Individuals who have been identified are, left to right, second row, Frank Bishop, Elmo Davis, Lee Morris, Erwin Davis, (third row) Emeral Vinnedge, Everett Vinnedge, and ? Olonia.

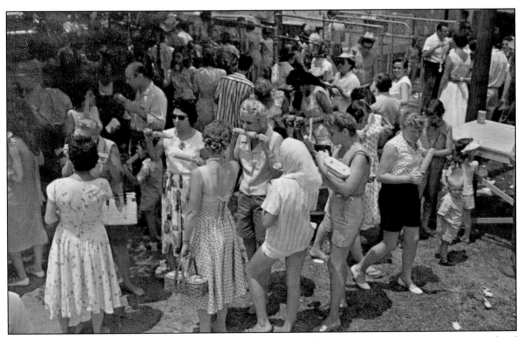

LA HABRA CORN FESTIVAL. Started in 1949, a Lions Club dance and cookout event evolved into the now famous La Habra Corn Festival. This 1959 photograph shows a group of happy people enjoying freshly prepared corn on the cob.

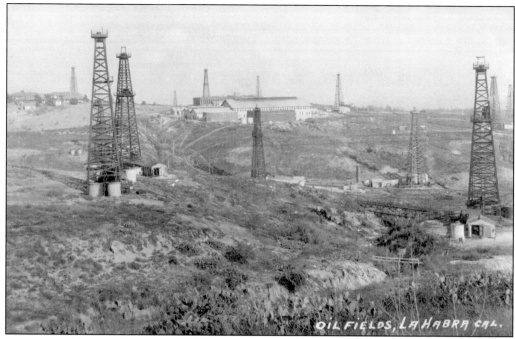

STANDARD OIL FIELDS. In 1895, the Puente Oil Company produced oil in the La Habra area. In 1912, the Standard Oil Company began to successfully drill for oil in the area of the West Coyote Hills. These are the Standard Oil Fields around 1920.

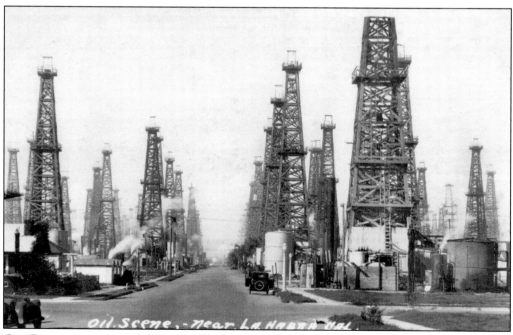

OIL DERRICKS NEAR LA HABRA. During the early part of the 20th century, oil became the black gold of California. This picture illustrates the huge development of that industry near La Habra and the surrounding area.

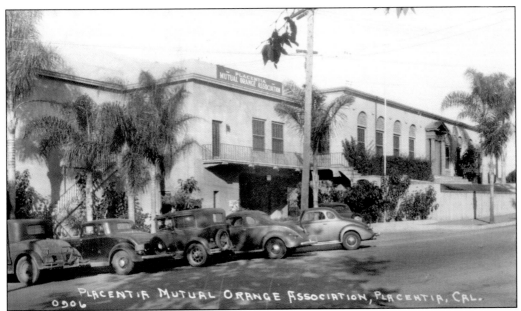

PLACENTIA MUTUAL ORANGE ASSOCIATION. Samuel Kraemer Jr. built Placentia's first packinghouse in 1910–1911. Local leaders such as John Nenno, Sam Kraemer, John Tuffree, and Benjamin Kraemer founded the Placentia Mutual Orange Association. In 1920, the group bought a new site and built a modern and spacious building on the corner of Melrose and Crowther Avenues. It still stands, serving as a reminder of Placentia's citrus heyday.

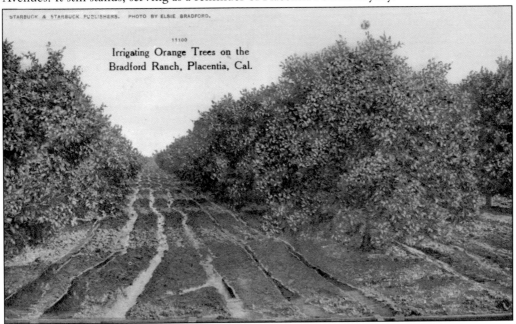

IRRIGATING ORANGES. In 1891, Albert S. Bradford came to Placentia from Massachusetts. He was a primary force in bringing the railroad to town in 1910 and in developing the downtown area. Valencia oranges brought great wealth to the community and, in 1911, Bradford built his own packinghouse to ship fruit grown on his ranch. In 1918, he sold the packinghouse to R. T. Davies. The structure burned down on November 11, 1921.

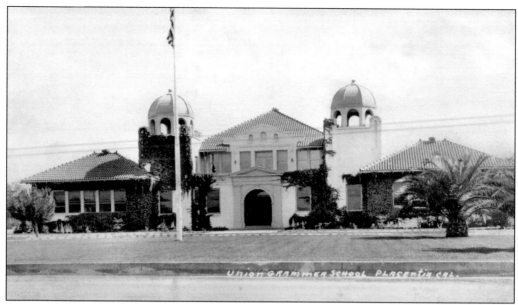

UNION GRAMMAR SCHOOL, 1924. Built in 1912, the school is known today as Valencia High School. Additions were made in 1920 to accommodate the growing number of students. Parts of the older building are still used today by the high school.

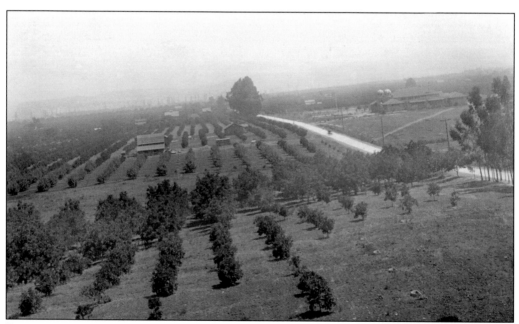

BRADFORD AVENUE LOOKING NORTH, 1917. A pastoral scene of Valencia orange groves illustrates Placentia's early days as a citrus production center. The soil was ideal for growing fruit. Crops were shipped to markets on the East Coast as well as internationally. In 1915, Placentia alone shipped over 1,000 railcars of the golden fruit. Visible in the background on the right are the twin domes of Union Grammar School.

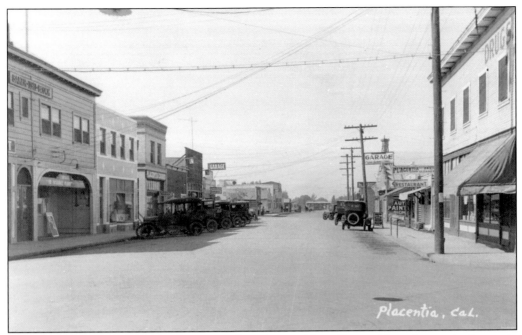

PLACENTIA BANK BLOCK. According to longtime resident George Key, the movie theater in downtown Placentia was on the southwest corner of Santa Fe Avenue and Main Street. Hand-operated reels had to be turned to make the movies "move." In this postcard, the building in the front left corner is the "Bank–1911–Block" and below it is the Placentia Theater.

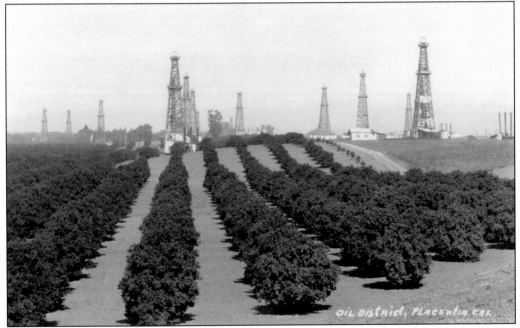

OIL BROUGHT CHANGE. Oil brought great wealth to Placentia along with the heavy equipment, commotion, and people seeking fortunes. Wooden derricks measured 24 feet square at the base and were usually 100 feet tall. They changed the look of the rural landscape, as seen in this postcard.

PLACENTIA DEPOT, 1920. On the south side of Santa Fe Avenue and the east side of Bradford Avenue stands the town's depot, built in 1911. The railroad arrived in 1910 and proved to be of great importance as Placentia shipped locally grown oranges throughout the country.

JOHN NENNO RESIDENCE, 1915. Pioneer John Nenno arrived in the area in 1892 and found work as an orchard fumigator. His lovely home was built in 1907 and today is used as a professional building, located at the corner of Placentia Avenue and Palm Drive. The names of his two daughters, Beatrice and Faustina, are handwritten on the front of the postcard.

HOLLOWAY'S CASH STORE. This 1920s scene looks north on Olinda Street in downtown Yorba Linda. Leaders in town, the Holloway family owned and operated this store. The sign on the side of the building reads "The Store with the Goods and the Prices." Across the street, not shown in this view, is the building housing the Yorba Linda Post Office and dry goods store.

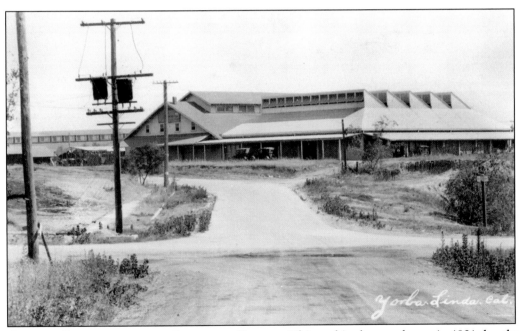

ORANGE PACKINGHOUSE OF FOOTHILL GROVES. This packinghouse, shown in 1921 shortly after construction was completed, was located on Front Street near the intersection of Yorba Linda Boulevard and Imperial Highway. Foothill Groves merged in 1929 with the Yorba Linda Citrus Association. The packinghouse was used into the 1960s.

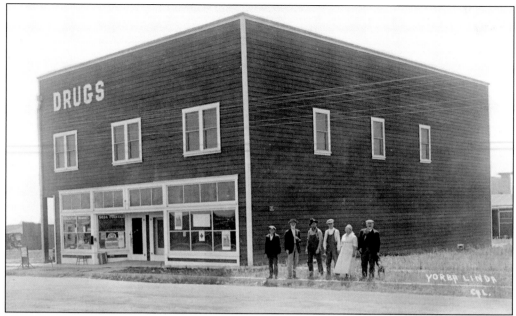

DRUG STORE, 1920S. Located on Main Street, this drug store once served as the location of Yorba Linda's city hall. Owned and operated by Doc Cannon, his drugstore was the "in place" for teens and young adults to hang out.

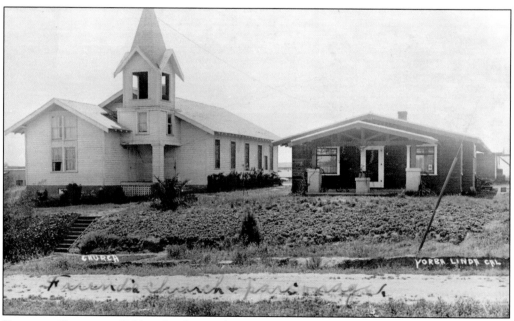

FRIENDS CHURCH, 1920S. Quaker settlers came to Yorba Linda from Whittier during the early part of the 20th century. Built in 1912 on School Street, this church still stands today. The building to the right is the parsonage. In 1937, the church's 25th anniversary was celebrated with a huge picnic. Pres. Richard Nixon's family were members and attended services here. By 1962, the membership had outgrown the building and a second Friends Church was constructed on Rose Drive.

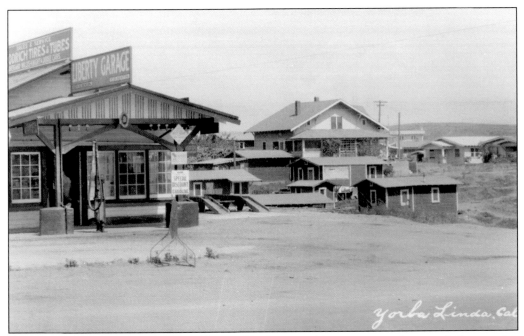

LIBERTY GARAGE, 1920s. Owned by Hurliss Barton, this garage was the town's first service station, located at Main Street and Imperial Highway. In 1912, Barton and his parents moved to Yorba Linda from Whittier. The first city park was named in his honor. Barton's sons still own and operate a garage/Chevrolet dealership now located on Imperial Highway, west of town.

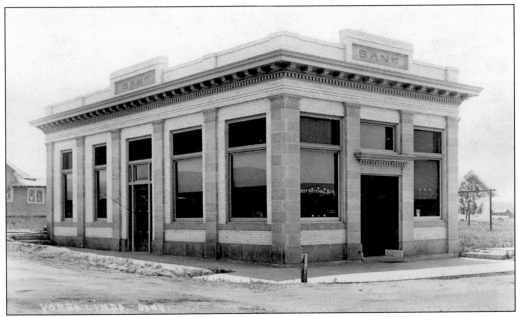

BANK, 1920s. In 1917, John Barton built the first bank, First National Bank of Yorba Linda. It was a viable financial institution until 1932 when the Depression forced its closure. It would be 13 years before another Yorba Linda bank opened its doors. The old building was razed during the 1960s to make way for a modern bank building.

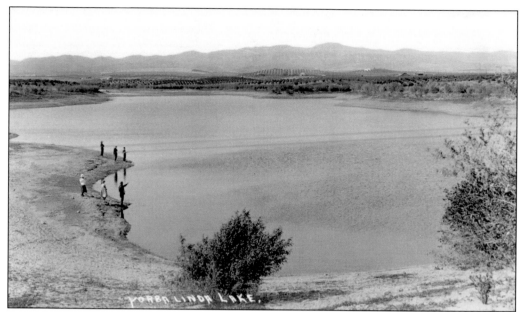

YORBA LINDA LAKE. Now a dry nature area providing walking and horse trails, the lake previously served as the community's water storage from 1902 to 1969. The Navarro family were *zanjeros* (water watchers) for the Anaheim Union Water Company. Their home was located on the southeast rim of the reservoir. Today Navarro family members still live in homes on the dry lake's edge.

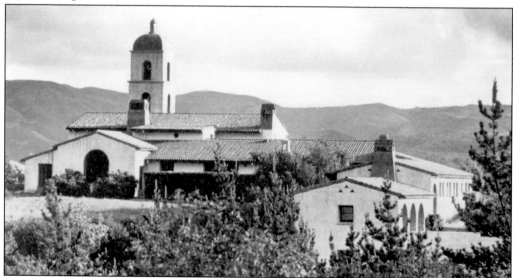

RANCHO SANTA ANA BOTANIC GARDEN ADMINISTRATION BUILDING. Developed in 1927, the garden was the dream of Susanna Bixby Bryant. She was a member of the Bixby family that founded Long Beach, California. In 1875, her father, John, purchased land from the heirs of original grantee Bernardo Yorba from part of his Rancho Santa Ana. Susanna Bixby Bryant enlisted top scientists and botanists to help nurture her garden. Although California native plants were the specialty, florae from all over the world were brought to the Santa Ana Canyon (present-day Yorba Linda) garden showplace. The garden was relocated to the city of Claremont in 1951 after Bryant's death. The mission-inspired administration building shown here was demolished.

Three

WEST
BUENA PARK, GARDEN GROVE, LOS ALAMITOS, MIDWAY CITY, STANTON, AND WESTMINSTER

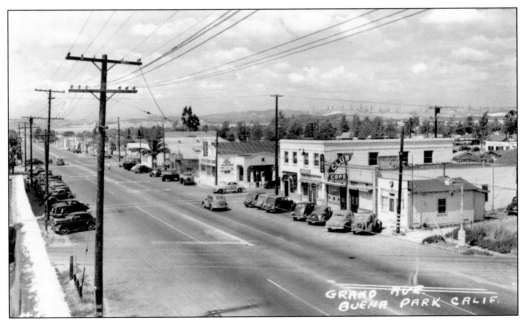

BUENA PARK. It seems the name Buena Park is derived from *plaza buena* meaning "good or nice park" in Spanish. Plaza Buena was located near the present-day intersection of Artesia Boulevard and Beach Boulevard. The 1940s view on this postcard is to the north on Grand Avenue (Beach Boulevard/Highway 39). Crossing Grand Avenue in the foreground are the Southern Pacific Railroad tracks. The Coyote Hills are in the background with oil derricks on the hilltop.

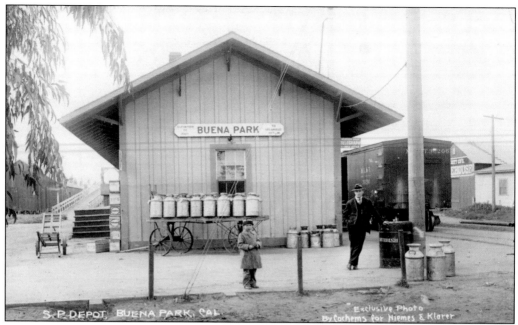

SOUTHERN PACIFIC RAILWAY DEPOT, BUENA PARK. Survival and success for Buena Park centered on the Southern Pacific Railway Depot. Shown here in 1914, milk cans await shipment to the creamery. From the ramps on the left, wagons dropped off sugar beets into railcars waiting below. A prominent photographer of Orange County scenes, Edward Cochems, whose work spanned the years from 1910 into the 1940s, took the photograph from which this postcard was made.

THE FIRST CONGREGATIONAL CHURCH OF BUENA PARK. This church building was dedicated in 1891, the parsonage at the left came later. James A. Whitaker, founder of Buena Park, donated a "100 foot square" area for the church.

BUENA PARK GRAMMAR SCHOOL. Buena Park's second grammar school, shown here about 1909, was simply called Buena Park School. The first school building was built and rebuilt several times.

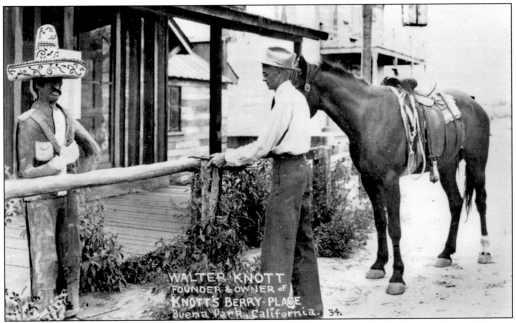

KNOTT'S BERRY PLACE. Walter and Cordelia Knott founded and built Knott's Berry Place, a full-blown market and nursery that evolved from their original roadside fruit stand. This was the beginning of the famous Knott's Berry Farm and Ghost Town. Their children and grandchildren all worked at the farm. It was the beginning of the tourist industry in Orange County. The family sold the theme park to Cedar Fair, L.P. in December 1997.

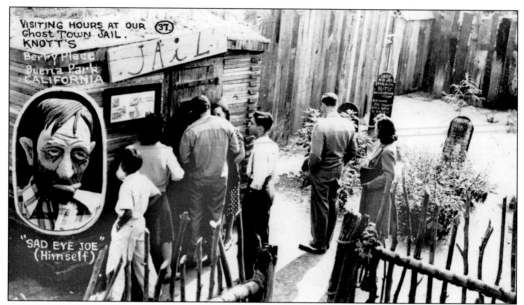

"Sad Eye Joe." At Knott's Berry Farm, Sad Eye Joe was a resident of the Ghost Town jail. A visitor might be surprised when Joe would know his name and other personal information. The visitor's host had supplied the information to a vendor around the corner who was Sad Eye's voice.

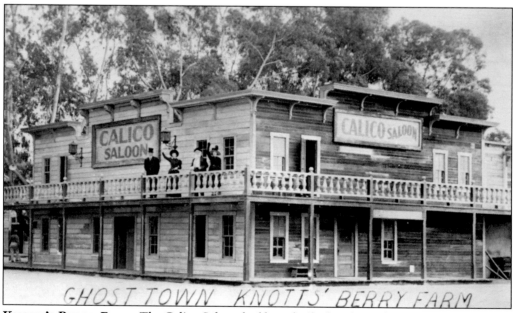

Knott's Berry Farm. The Calico Saloon had been built elsewhere, dismantled, and brought to Buena Park. It was Walter Knott's practice to bring in buildings from deserted ghost towns to make his Ghost Town authentic.

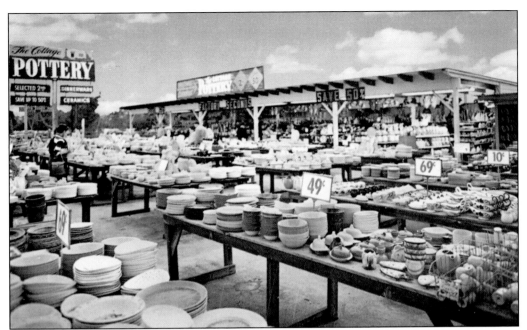

BUENA PARK, COTTAGE POTTERY. The business opened in 1949 on busy California State Highway 39 (Beach Boulevard). It was one of the many businesses basking in the proximity of Knott's Berry Farm. Closed in the 1980s, the area developed into a strip mall.

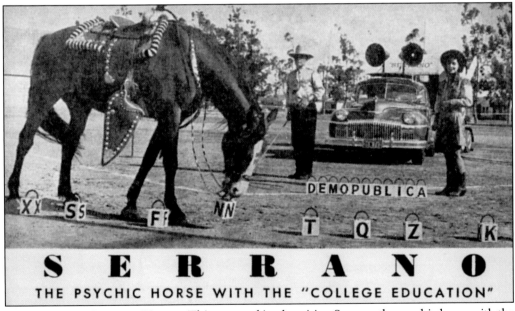

SERRANO THE PSYCHIC HORSE. This postcard is advertising Serrano the psychic horse with the "college education," who was seen performing throughout the county. He frequently appeared at Knott's Berry Farm. In 17th century France, a famous "talking" horse named Morocco could perform mathematical calculations and other feats. Such animals respond to secret cueing from their trainers.

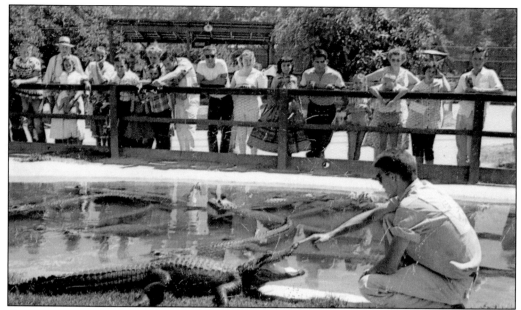

CALIFORNIA ALLIGATOR FARM. The California Alligator Farm was across from Knott's Berry Farm at 7671 La Palma Avenue. Another venture taking advantage of the Knott's Berry Farm lure, it featured not only alligators, but also other reptiles. It operated from 1953 to 1983.

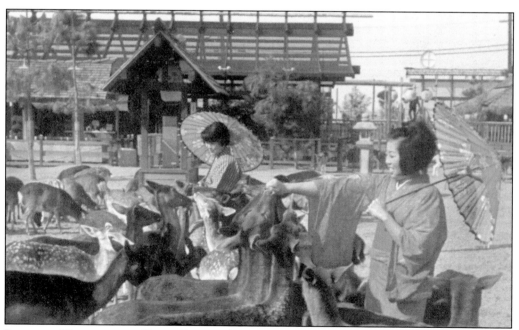

JAPANESE VILLAGE AND DEER PARK. This beloved attraction opened in Buena Park in 1967 and closed seven years later. Visitors were enticed by traditional Japanese landscaping, artifacts, and gourmet food along with a myriad of animal shows with individual performances by lions, tigers, dolphins, deer, macaws, and bears. This card shows attendants in traditional dress feeding the deer. It was located on the corner of Knott Avenue and Artesia Boulevard.

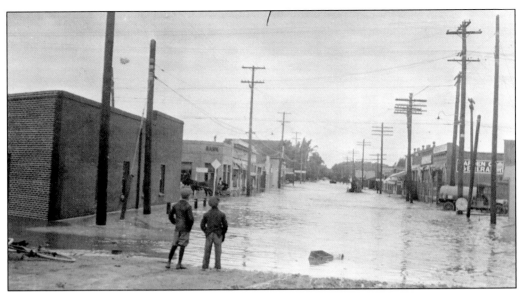

GARDEN GROVE, 1916. When the Pacific Electric Railway was constructed across West Orange County in 1905, no provision for culverts was made and the three-a-half-foot-high railway embankment created a huge dam. In 1916, water backed up on the north side of the embankment, flooding the town. Unknown persons used dynamite to open the dam, saving the town. This flooding problem would persist into the 1950s.

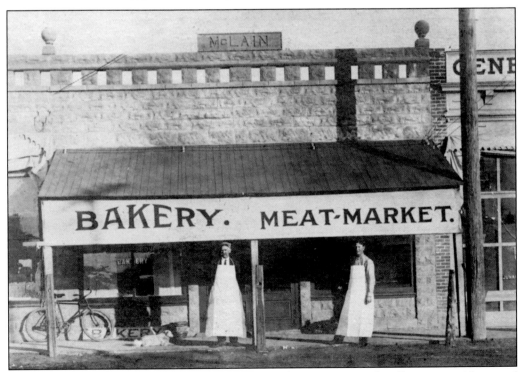

BAKERY/MEAT MARKET, GARDEN GROVE. Garden Grove was a bustling town with several bakeries, meat markets, and dry goods stores located in the downtown area into the 1950s. The sign on top of this building reads McLain.

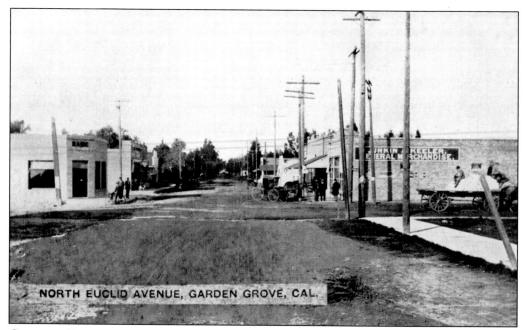

NORTH EUCLID AVENUE, GARDEN GROVE, CAL.

GARDEN GROVE, C. 1910. The town was a growing crossroads farming community. The Pacific Electric Railway had come through in 1905. Businesses began to sprout, including the Junkin and Keeler General Merchandise Store, opening in 1907, and the Bank of Garden Grove, opening in 1909.

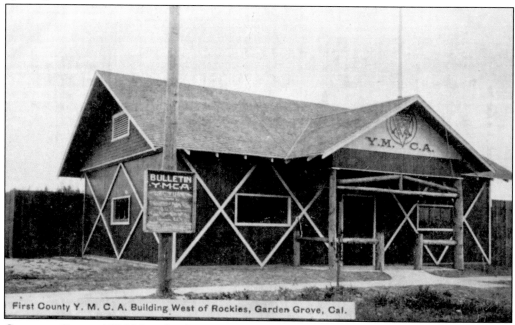

First County Y. M. C. A. Building West of Rockies, Garden Grove, Cal.

GARDEN GROVE YMCA. The first Young Men's Christian Association west of the Rocky Mountains was founded in Garden Grove sometime after 1910. The first postmaster, David Webster, had been instrumental in founding the Young Men's Christian Association in England before coming to this country. The Garden Grove YMCA became a community meeting hall. A McDonald's now occupies this lot at Walnut Street and Garden Grove Boulevard.

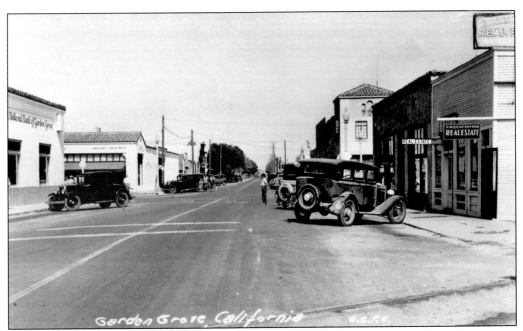

POST–1933 EARTHQUAKE. Looking east, Ocean Avenue (Garden Grove Boulevard) is shown after the 1933 earthquake. The community decided on a uniform architectural style: white walls and red tile roofs. On the near left is the First National Bank of Garden Grove. Across the street (Euclid) is Schneider's Grocery Store. On the right is the Garden Grove Hotel and near right is Reafsnyder's Real Estate office.

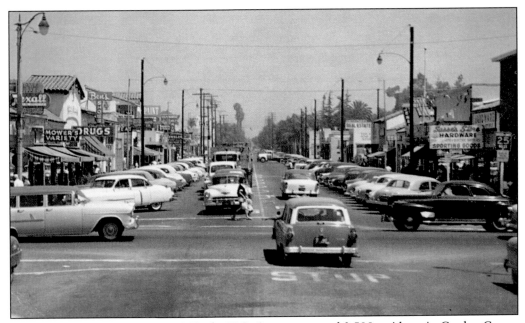

GARDEN GROVE IN 1956. In 1950, the U.S. Census counted 3,500 residents in Garden Grove. In 1956, the year of incorporation, there were over 42,000 people in the area.

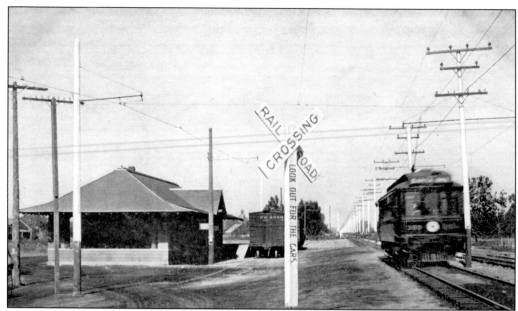

PACIFIC ELECTRIC RAILWAY. In 1905, the Pacific Electric Railway came through "downtown" Garden Grove. In 1914, the station was built. In this scene, a Red Car is headed from Los Angeles toward Santa Ana. "Look Out for the Cars" was an apt admonition.

METHODIST EPISCOPAL CHURCH. The original First Methodist church was the first church established in the community. The building grew from a small frame structure in the 1870s to this handsome edifice seen here in 1910.

LINCOLN SCHOOL. The Lincoln School in Garden Grove was the first consolidated grammar school, replacing two other schools, and opening in 1908. An imposing structure, it held offices, nine classrooms, and an upstairs auditorium with a capacity for 250 people.

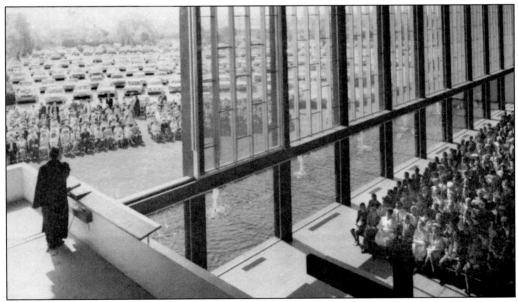

GARDEN GROVE COMMUNITY CHURCH. In 1955, Rev. Robert Schuller started his Orange County ministry on top of the snack bar at the Orange Drive-In Theater. It evolved into the Crystal Cathedral designed by the noted architects Phillip Johnson and his partner John Burgee. The message on the reverse side reads, "Come to the Walk-in/Drive-in church with seating for 1,000 inside the church and another 1,500 people, in cars, parked in 10 landscaped acres."

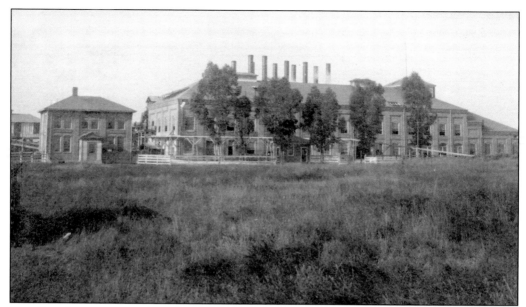

THE LOS ALAMITOS SUGAR FACTORY. The Los Alamitos Sugar Factory was the first of its kind in Orange County. Erected in 1897, by 1920 it had contributed over $7 million to the Orange County economy. More than 10,000 acres were devoted to sugar beets in Orange County.

A COMPANY TOWN. Los Alamitos was a "company" town. The sugar factory (center top of the card) was THE industry in town and almost everyone worked for the company. Many were seasonal workers, young and unattached. The town had a lively nightlife, with pool halls, bars, and two hotels, giving a Wild West flavor to the town.

MIDWAY CITY. This advertisement was on Highway 39 in Midway City. The Peek Family Colonial Funeral Home is still in business today. John Harper, who purchased the land and developed the town, chose the name Midway City. It is six miles from Huntington Beach, six miles from Santa Ana, and seven miles from Long Beach, thus inspiring the name.

STANTON. Pictured here is a fine home built in rural Stanton. A family might admire a house in town and have it duplicated in a less urban setting. The city of Stanton was named for Philip Stanton, a prominent Seal Beach landowner and developer.

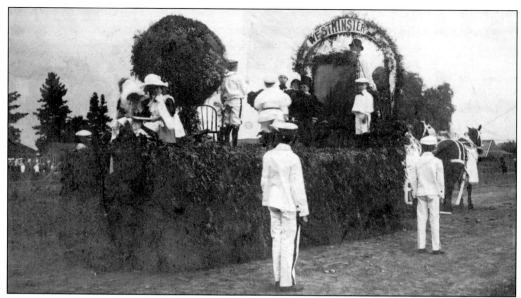

WESTMINSTER. This is Westminster's contribution to the Parade of Products held in Santa Ana in the early years of the 20th century. The settlement of Westminster was founded in 1870 by a Presbyterian reverend, Lemuel P. Webber, with his purchase of some 6,000 acres of the Stearns Ranchos. Over the next five decades, products that shipped from this agricultural colony were celery, grapes (briefly), sugar beets, lima beans, and milk products from the dairies. This float represents the pride the citizens of Westminster felt for their town.

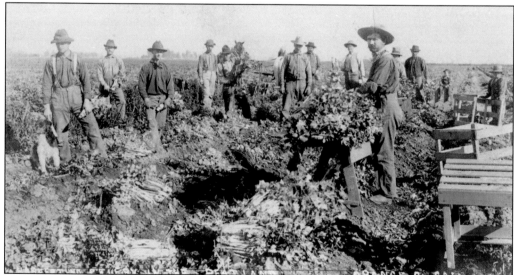

CELERY FIELD HARVEST BOXES AND WORKERS. The celery industry was introduced to the county by D. E. Smeltzer, a Michigan celery shipper, who came to Southern California in 1890 in search of land suitable for the crop. Finding wild celery growing in the peat bogs south of Westminster (the locals called the area Las Cienegas), Smeltzer and E. A. Curtis leased land and unsuccessfully tried to grow the crop. Later efforts by the Earl Fruit Company were successful, and by 1904, they shipped more than 1,800 railcar loads. However, by 1906, the fertility of the land began to decline. Weakened celery plants were struck by blight and eventually were replaced by beans and sugar beets.

Four

WEST COAST
CORONA DEL MAR, COSTA MESA, HUNTINGTON BEACH, NEWPORT BEACH/BALBOA, SEAL BEACH, AND SUNSET BEACH

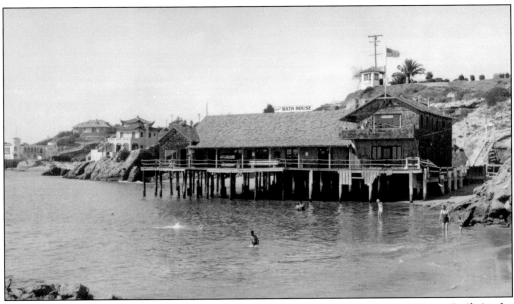

ADVERTISEMENT FOR SPARR'S PUBLIC BATH HOUSE IN CORONA DEL MAR. Built in the early 1920s as part of the Balboa Palisades Club, Sparr's Public Bath House became the unofficial headquarters for the famed Corona del Mar Surf Board Club, at that time said to be the largest surf board club in the United States. The back of this postcard reads: "A location used in 1938 for the Paramount Movie 'Spawn of the North' featuring George Raft, John Barrymore, Henry Fonda and Dorothy Lamour. A false second story was put on this bath house. This was supposed to be Ketchikan, Alaska. Real scenes from Alaska were worked into the background. 'Flicker' the seal jumped out of the second story." The cinematography and sound effects won a special Academy Award. In the early 1940s, the bathhouse was badly damaged in a fire and was never restored.

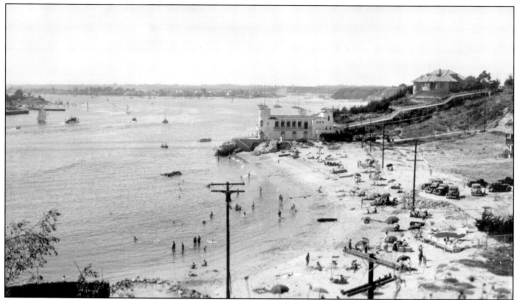

CORONA DEL MAR NEWPORT HARBOR ENTRANCE, 1930S. The building on the point is the Kerckhoff Marine Laboratory, built in 1926 as a boat and bathhouse for the short-lived Balboa Palisades Club. Because of the club's financial problems, the building was sold to the California Institute of Technology about 1929 and became its marine lab, named for Kerckhoff, a prominent Caltech benefactor.

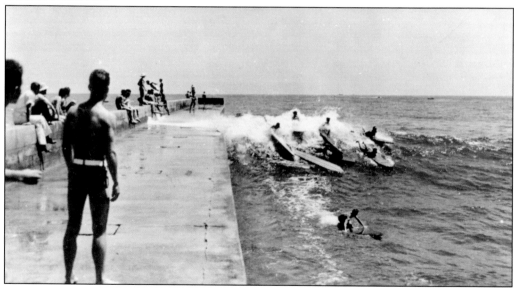

EARLY SURFERS AT CORONA DEL MAR. By the 1920s, Corona del Mar had gained a reputation for the most spectacular surfing in Southern California. In August 1928, the Corona del Mar Surf Board Club hosted the Pacific Coast Surf Board Championships. Members of the club included such surfing greats as Duke Kahanamoku of Hawaii, Tom Blake of Redondo, and Gerald and Art Vultee of the Los Angeles Athletic Club. Shown here is the cement jetty, built in 1928. By the mid-1930s, the extension of the east and west jetties, and the dredging of the channel benefiting the boating and development of Newport Harbor ended the golden era of surfing at Corona del Mar.

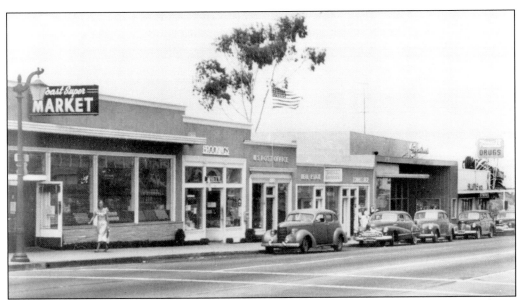

POST OFFICE, CORONA DEL MAR, LATE 1940S. This postcard shows one of the earlier (from 1941 to 1952) Corona del Mar post office sites located on Pacific Coast Highway, between Marigold and Narcissus Avenues. Because of the big debate over "Del vs. del" (when the post office first opened in 1926, it was spelled with a capital "D"), on April 1, 1950, the post office officially closed for one day and reopened as the Post Office of Corona del Mar, 92625. The zip code had also been a problem. Officially Corona del Mar had been part of Newport Beach since 1924, but now was out of the numeric zip sequence. In 1952, the post office moved to its present location at 406 Orchid Avenue, with mail addressed to Corona del Mar.

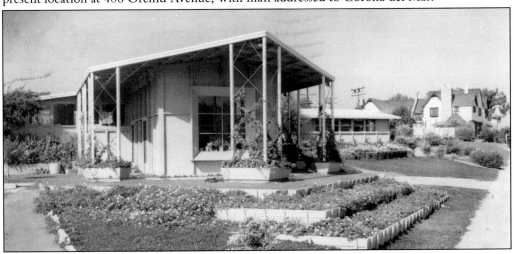

KAY FINCH STUDIO 1947. Kay Finch Ceramics was operated by Kay and her husband, Braden. They had a place on Hazel Drive, a block east of Poppy Avenue in Corona del Mar. They bought a vacant lot, around the corner on Coast Highway, just east of what is now the Five Crowns Restaurant, and built this facility to house their rapidly expanding business. The grand opening was on Sunday, December 7, 1941. Military officials soon demanded that they change the building's roof shape, saying it was like a giant arrow pointing towards El Toro Marine Air Station. By 1947, Kay Finch Ceramics employed nearly 70 people and her creations were found in over 2,000 stores in 19 countries. A retirement facility now occupies the site.

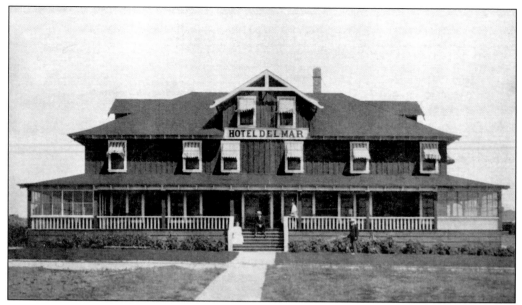

ADVERTISEMENT FOR HOTEL DEL MAR, 1915. The hotel was built in 1907 and was intended to be the clubhouse for the Balboa Palisades Club. George E. Hart bought the land from the Irvine Company. Meals were sometimes served on the wide veranda when weather allowed. The back of this postcard states: "At Corona del Mar, seated on towering cliffs, 80 feet above the tide, overlooking both bay and ocean, and commanding one of the grandest and most inspiring views in Southern California."

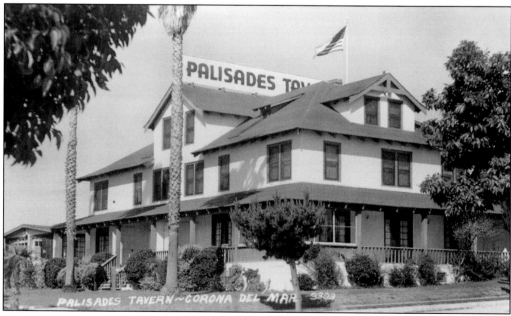

PALISADES TAVERN, 1942. This is a "reincarnation" of the Hotel Del Mar. The building was three stories, with 30 small rooms, a dining room, kitchen, office space, a fireplace in the lobby, and a ladies parlor. The hotel was originally lit by gaslight when it was built in 1907. The upper floors each had 10 rooms, with one bathroom per floor. The Tavern was located at Thirtieth and Fifty-first Streets, now Seaview and Carnation.

BUFFALO RANCH BARN. Gene Clark leased 115 acres from the Irvine Company in 1954 on the northeast corner of the intersection of MacArthur Boulevard and today's Bonita Canyon Drive (formerly Ford Road). His idea was to open a drive-through amusement-park style buffalo ranch. When a herd of 72 buffalo were brought in from Kansas, the unloading was witnessed by hundreds of people. The Buffalo Ranch closed in 1959 because the Irvine Company failed to renew the lease. In 1961, architect William L. Pereira Associates acquired the property, including the striking silo and barn, as the Orange County headquarters of his firm. More barns were added, renaming the site Urbanus Square. The firm created the master plans and early building designs for the UCI campus and Newport Center. Bison Avenue in the East Bluff tract of Newport Beach and a large buffalo statue near Newport Center commemorate the amusement park.

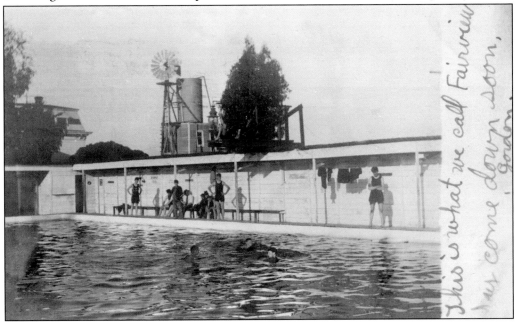

THE PLUNGE IN FAIRVIEW. Fairview was a boomtown in 1887, but went bust by 1889. This short-lived town was known for its hot springs and was originally located at today's busy intersection of Harbor Boulevard and Adams Street. In 1904, W. S. Collins, a land developer in Newport Beach and Balboa, refurbished and reopened the Fairview Hotel and Hot Springs.

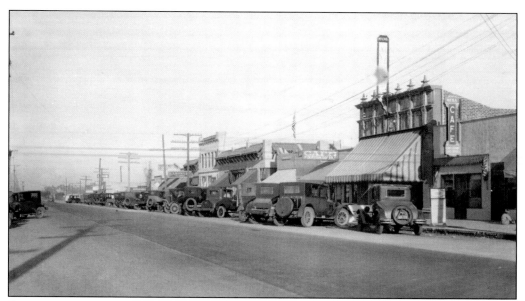

DOWNTOWN COSTA MESA, 1920S. Here is a view of downtown Costa Mesa along Newport Boulevard looking north from Eighteenth Street towards the county seat of Santa Ana. Today this busy street serves travelers visiting the picturesque beaches of Balboa and Newport Beach. Note the white sign on sidewalk in front of the Mesa Cafe on the right. It reads, "Santa Ana Laundry, Leave bundles here." According to the Santa Ana *Daily Evening Blade* in 1899, the Santa Ana Steam Laundry had drop-off sites in many communities.

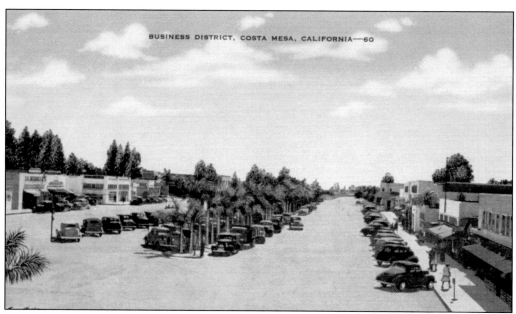

BUSINESS DISTRICT, COSTA MESA. This postcard shows a view of Newport Boulevard looking south towards Newport Beach. The parking lane was placed in the middle of the street so the town's annual fish fry could be held without holding up traffic. Among the most celebrated events in Costa Mesa, the annual Lion's Club Parade and Fish Fry began in 1946 and is still celebrated the first weekend in June.

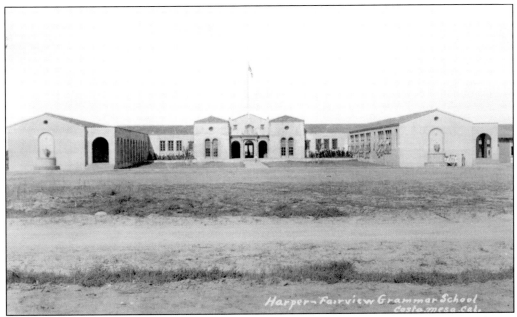

HARPER-FAIRVIEW SCHOOL (COSTA MESA GRAMMAR), 1920S. Located at the northwest corner of Nineteenth Street and Newport Boulevard, the school was constructed during 1922 and 1923. It had six rooms. Both Harper and Fairview were names once used to describe the area now known as Costa Mesa. The school was overcrowded by 1924, and five additional rooms were built to ease the problem.

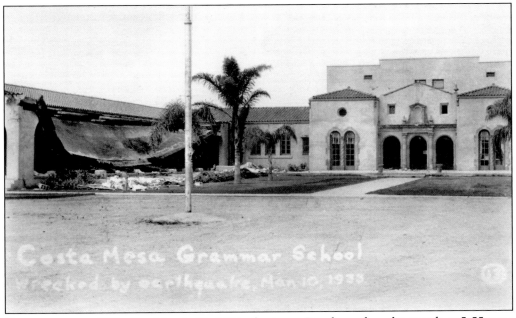

EARTHQUAKE, 1933. On March 10, 1933, the Long Beach earthquake struck at 5:55 p.m. The damage was widespread throughout Orange County and Costa Mesa suffered, especially in the business district. Shown here is the collapsed covered walkway at the Costa Mesa Grammar School.

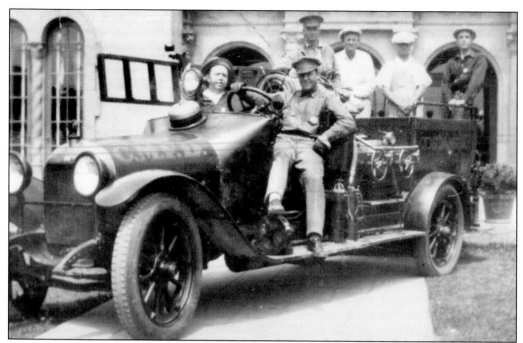

COSTA MESA VOLUNTEER FIRE DEPARTMENT. Costa Mesa's first fire chief was elected in 1925, and the first order of business was to organize a volunteer fire department. Merchants paid dues of $4 a year to be members of the chamber of commerce and with that received fire protection.

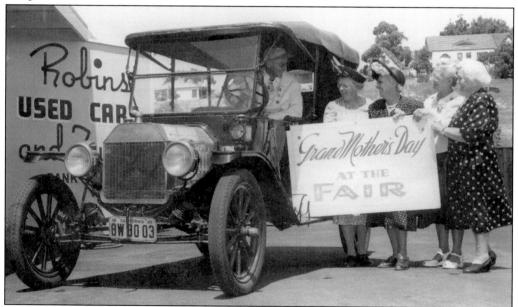

GRANDMOTHER'S DAY AT THE FAIR, 1947. After World War II, the Orange County Fair moved to the site of the Santa Ana Army Air Base (SAAAB) in Costa Mesa (today the fairgrounds and Orange Coast College occupy the site). Started back when the county was formed in 1889, the fair has grown from displaying only agricultural exhibits to celebrating the many facets of Orange County life.

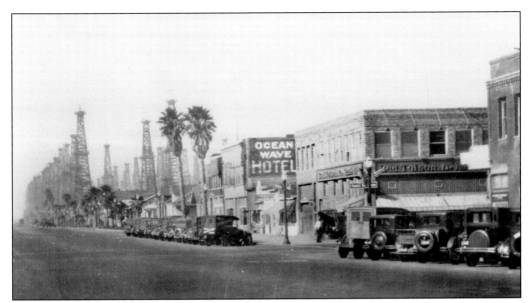

PACIFIC COAST HIGHWAY, HUNTINGTON BEACH. Looking north on Pacific Coast Highway in Huntington Beach, one sees in the distance the forest of wooden oil derricks, which blighted the area for many decades. In 1919, Standard Oil leased land on the "mesa." In May 1920, the first well came in. Soon more oil wells were in production. By 1930, the annual output at Huntington Beach reached 1.1 million barrels of oil.

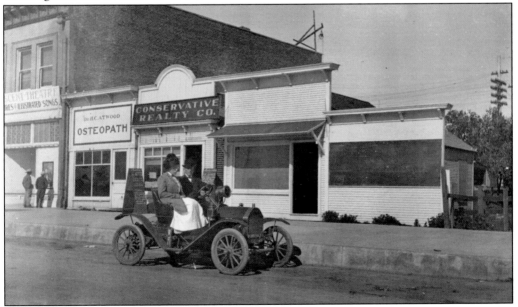

MAKING THE ROUNDS, DR. CLARK AND HIS NURSE. Dr. John Clark and his nurse Miss White may have been visiting patients in the Huntington Beach area. The images depicted on this postcard date from the 1908–1912 eras, around the time of the city's incorporation. The building to the left (partial view) is the Ocean Wave Hotel, then the office of Dr. Atwood, an osteopath. Dr. Atwood moved to Riverside in 1910. Next to that is a real estate office. Dr. John Clark graduated from Rush Medical School in Illinois and practiced medicine in Santa Ana from 1904 until his death in 1937.

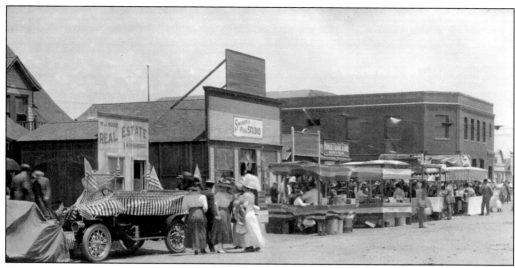

"SOMETHING DOING IN HUNTINGTON BEACH," MAIN STREET FAIR. With its good weather, Huntington Beach was a natural locale for parades and conferences. Shown here are street vendors with various goods for sale from their wagons. The two-story brick building houses the Corner Confectionery operated by Erwin Vincent, who also served as the marshal around 1913. Vincent did not remain for long by the seashore, moving on to several inland regions of California.

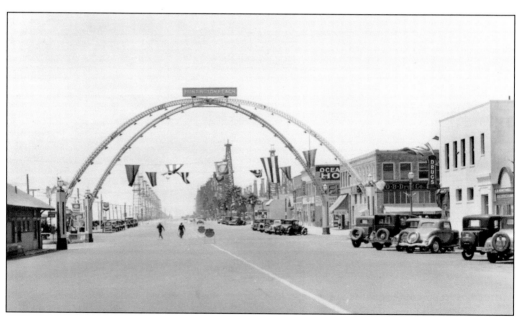

HUNTINGTON BEACH GATEWAY ARCHES. The arches were a civic project of the early 1930s. Many banners and Christmas decorations were displayed from these arches. Noted on the "box" at the apex of the arches is "Huntington Beach." Saltwater and corrosion eventually forced the removal of the arches for safety reasons. In 1926, the 80-foot-wide Ocean Boulevard was incorporated into the Pacific Coast Highway when it reached Huntington Beach.

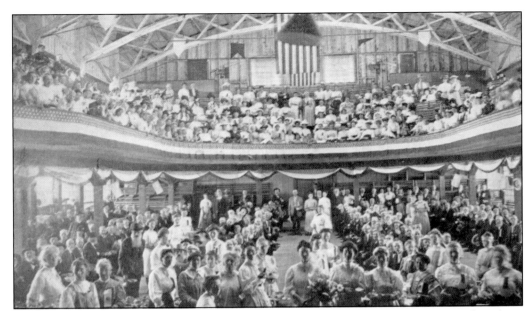

"THE TABERNACLE." The Epworth League was an organization for young people, whose motto was "Look Up, Lift Up." In 1906, the Southern California Methodist Conference decided to relocate from Long Beach to Huntington Beach and on April 16, construction began on the assembly hall—The Tabernacle. As many as 15,000 people gathered to hear speakers and participate in Bible studies. The conferences were held every summer. On the exterior, The Tabernacle resembled a large barn. In the 1930s, this structure burned down.

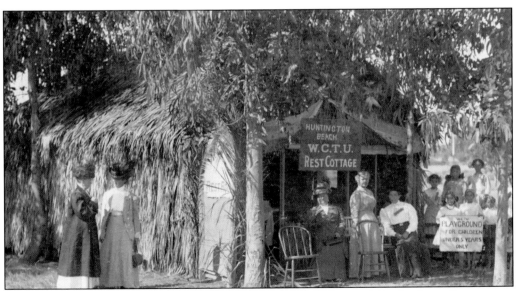

WCTU REST COTTAGE AND CHILDREN'S PLAYGROUND. In 1912, the Rest Cottage was built by the Woman's Christian Temperance Union (WCTU) at the Arbamar (Methodist) Campground. The cottage provided a respite for women and children from the sun, wind, and rigors of camp life. The WCTU program emphasized good citizenship, world peace, alcoholic abstinence, and narcotics education. Besides the adult program, there were grade school and high school level programs.

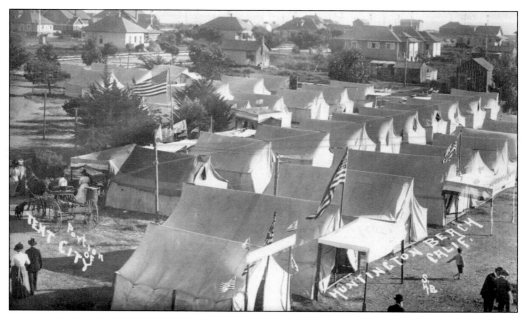

THE TENT CITY (CAMPGROUND). This tent city was part of the Arbamar Campground, which extended from Eleventh to Thirteenth Streets between Orange and Acacia Streets. These grounds were used by the Methodists, the Grand Army of the Republic (GAR), and the Woman's Christian Temperance Union (WCTU) during the summer months. This campground closed in 1920 to allow more derricks for oil drilling and extraction.

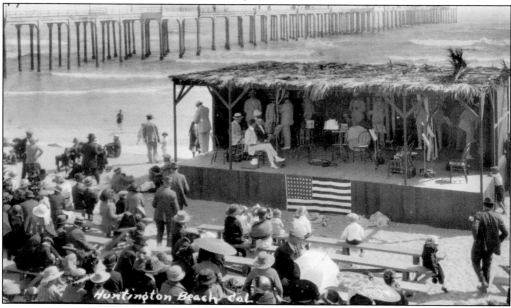

BAND CONCERT ON THE BEACH. The early wooden bandstands featured popular performers. Shown here, the audience is waiting for the band to return from an intermission. In the background is a portion of the 1,350-foot concrete pier, built in 1914 to replace the original 1,000-foot wooden pier (built in 1904). Storm damage in September 1939 required repairs to the pier, resulting in its extension to 1,822 feet by August 1940. In 1991–1992, it was demolished and replaced by a new pier.

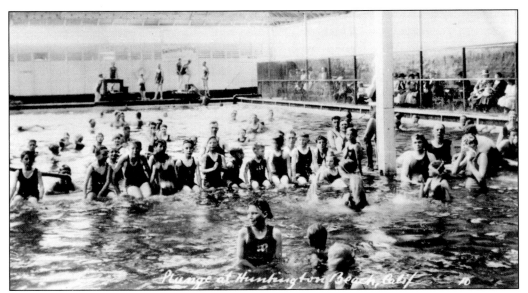

Plunge at Huntington Beach, Calif.

THE SALTWATER PLUNGE. This plunge was constructed on the beach a short distance west of the pier and was completed in 1911. Here the more timid souls could "bathe" in saltwater and not worry about riptides, undertows, or sharks. The enclosure seen in this image was erected during the 1920s. The plunge had a capacity of 150,000 gallons of saltwater with temperatures varying from 60 to 90 degrees. Around 1960, the entire structure was removed.

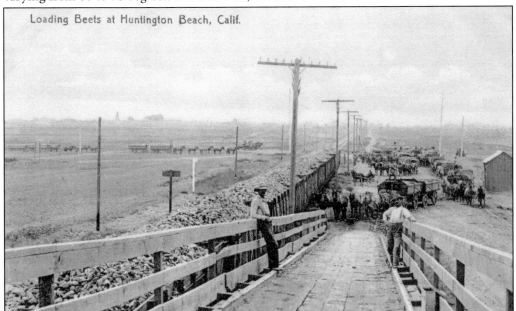

Loading Beets at Huntington Beach, Calif.

LOADING SUGAR BEETS INTO RAILCARS. Horse-drawn wagons are bringing sugar beets to a "beet dump" (the long wooden ramp) where the beets are dumped into railcars on their way to the factories. Sugar beets were big business in the early days—so big that at one time there were five sugar beet factories in Orange County. The first one opened in Los Alamitos around 1897. Between 1908 and 1914, four more factories opened: Huntington Beach, Anaheim, and two in Santa Ana. Sugar beet crop infestation by nematodes was a serious problem and difficult to eradicate. By 1930, only one factory in Santa Ana remained in operation.

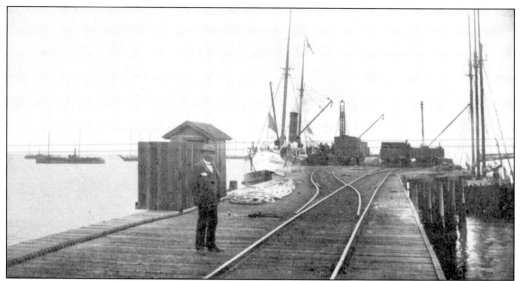

McFadden Wharf, Newport Beach, 1895. The wharf, built in 1889 for off-loading cargo from ships with deep drafts, was the beginning of Newport's glorious decade as a shipping port. The 11-mile railroad to Santa Ana from the wharf was completed in 1891 with passenger service beginning in July 1891. The amount of material to build this rail line to Santa Ana was determined by tying a rag to one spoke of a buggy wheel and counting the revolutions from the wharf to Santa Ana. The number of ties and rails needed for the railroad bed was figured by calculating the distance (number of revolutions times the circumference of the buggy wheel).

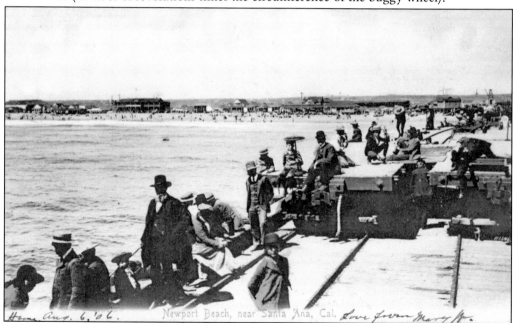

Visitors at McFadden Wharf, 1905. No longer a major shipping port, McFadden Wharf visitors are enjoying the view from the pier. Note that there are no guardrails on this pier. The McFadden brothers, James and Robert, drew plans for the City of Newport. They were among early settlers who recognized the future of Orange County and were influential in its development.

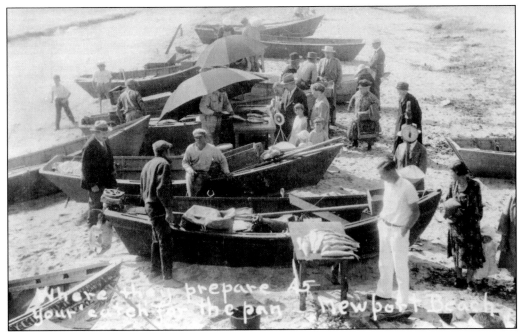

DORY FISHERMEN, 1920S. The dory fishermen are legends in Newport Beach. A small community comprised of dory fishermen and their families was established near the foot of the Newport Pier. The men would go out in the early morning to secure their catch, come back onto the beach by the pier in the early afternoon, then sell their fresh fish. This was a dangerous occupation and on many occasions the boats would capsize when returning through the surf. The fishermen would try to salvage as many fish as they could, but it was (and still is) a risky profession.

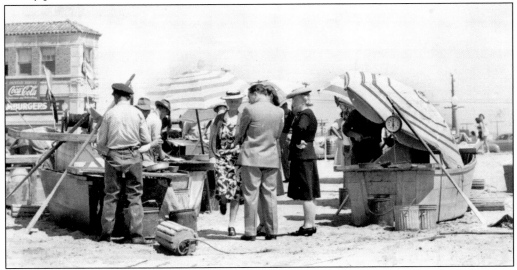

THE DORYMEN'S FISH MARKET, 1940S. It is interesting that the customers are so formally attired at the beach. Originally four men rowed each dory boat. With the introduction of outboard motors in the 1940s, the boats were pushed out of the shallows and then the engines were started. These engines allowed greater control of the boat and made coming in against the tide much easier.

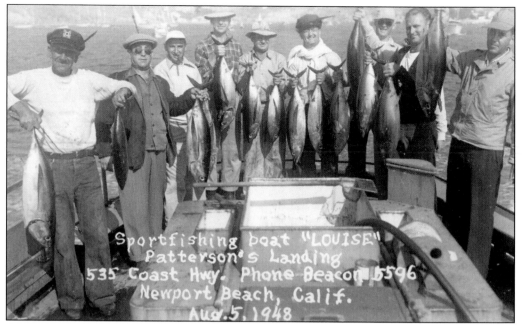

SPORT FISHING AT ITS FINEST, 1948. This appears to be an advertisement for the boats out of Patterson Landing in Newport Beach. It seems to say, "Come with us, we know where the fish will be biting!" Sport fishing boats are still active today out of Newport Beach, promoting the beach culture famous in Southern California.

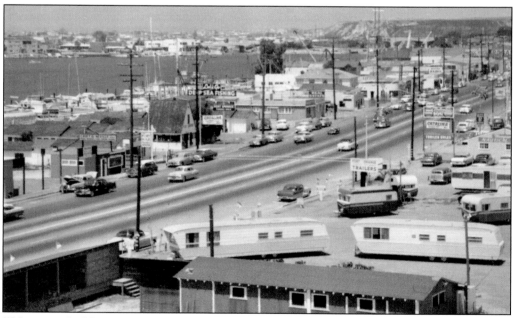

"MARINER'S MILE" ON COAST HIGHWAY, 1950S. Mariner's Mile was a hodgepodge of businesses. After the 1975 fire that leveled an entire block of Mariner's Mile on West Coast Highway between Tustin and Riverside Avenues, commercial architecture took a positive turn and generated well-designed buildings, most of which are still standing.

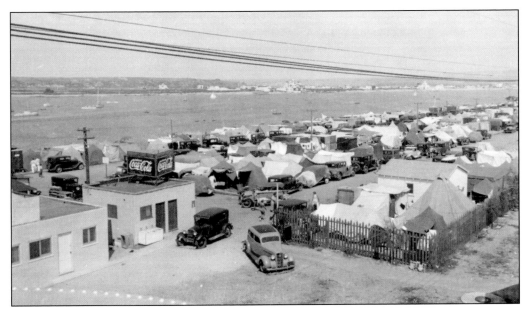

AUTO CAMP, 1936. The Newport Beach Municipal Auto Camp was located on West Bay Front Drive and the corner of Nineteenth Street. The first mention in the Orange County directory is in 1930, phone number 519. The last time it appears in the directory is 1941. A modern, upscale version of the auto camp can be found today at Newport Dunes in the Back Bay.

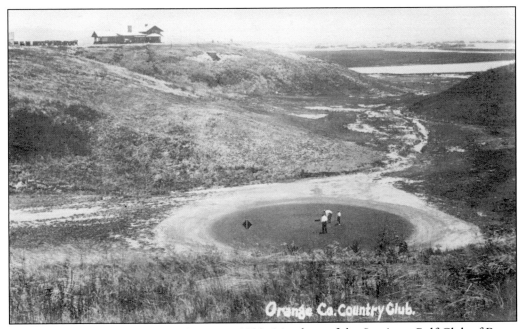

ORANGE COUNTY COUNTRY CLUB, C. 1920. Members of the Santiago Golf Club of Peters Canyon started this club around 1913 on the bluffs above Newport Bay. Then in 1923, a new group started the Santa Ana Country Club, which absorbed the Orange County Country Club. Later the clubhouse was called The Castaways, a restaurant.

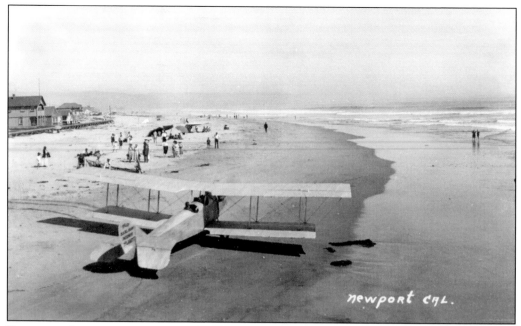

BEACHED AIRPLANE, C. 1919. This two-seater biplane landed on the beach at Newport *c.* 1919, drawing a crowd. The sand was firm enough for landing and takeoff. Note how shallow the beach is here. The tide is out which aided the pilot in his endeavor.

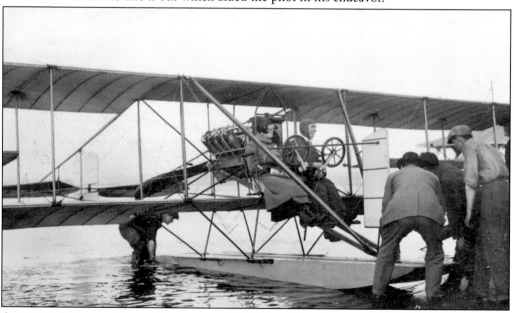

AVIATION PIONEER GLENN MARTIN, C. 1915. Glenn Martin, an early Orange County aviation pioneer, was fascinated with flying. In 1909, he began his career flying an airplane he designed and built himself. Working in a vacant church he rented in Santa Ana, he proved he could build a plane that could fly. On May 10, 1912, he was the first to fly a plane to Catalina, a distance of 26 miles that set a record as the longest, fastest (37 minutes) over-water flight. On May 10, 1963, a State Historical Landmark Plaque was dedicated in Newport Beach marking the site of this historic flight. The plane pictured here was one of his hydroplanes.

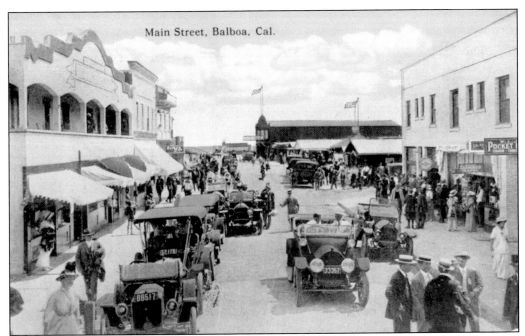

BALBOA'S MAIN STREET, C. 1914. Looking up Main Street from the pavilion, Madame LaRue's famous "theater" is beneath the flagpole at the pier. Madame LaRue (Osgood) imported ladies to compete in annual beauty contests because local girls "would never be seen in those costumes." They were very daring bathing suits because they had no skirts!

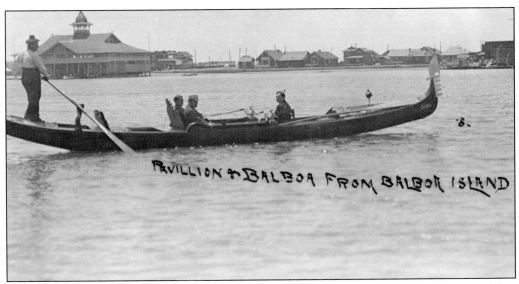

CROSSING THE BAY, JUNE 22, 1910. Before the ferry, one method of travel between Balboa Island and Balboa was by gondola. The passengers are on their way to the Balboa Pavilion, seen in the background. A Venetian gondolier named John Scarpa was credited with creating Balboa's first lighted parade, called the "Illuminated Water Parade," held on August 23, 1908. It later became known as the "Tournament of Lights," forerunner of today's pre-Christmas "Festival of Lights" in Newport Harbor.

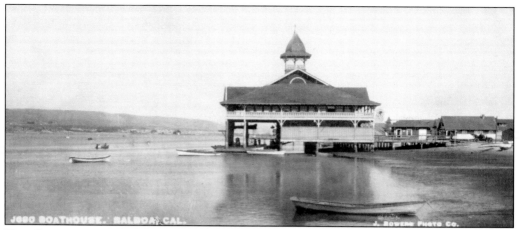

THE BALBOA PAVILION, 1910. This California Historical Landmark has been the center of fun and adventure ever since Chris MacNeil built the pavilion in 1905 for the Newport Bay Investment Company at a cost of $15,000. Over the years, the structure has housed gambling, bowling alleys, an art museum, restaurants, a dance hall, and sport fishing centers.

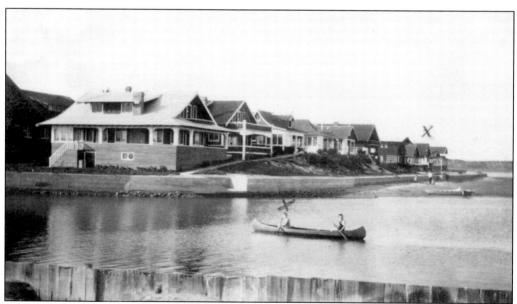

SOUTHEAST END OF BAY ISLAND. Shown here (from left) are cottage lots No. 1 through No. 10. In 1903, Rufus Sanborn bought this island, including property on the mainland for $350. Sanborn and Sam Tustin were the first to build on this little island, reached by a long plank trestle. Duck hunters had previously used this island, known then as Sand Island. Sanborn and Tustin formed the nonprofit Bay Island Club. The first 18 shareholders were well acquainted, as most had hunted ducks and played poker together at the Aliso Gun Club. They were farmers, land developers, and civic leaders well known in their communities. Among them were Hiram K. Snow, Sam Tustin, and Sherman Stevens of Tustin, and Edward Amerige, E. K. Benchley, and Dr. George C. Clark of Fullerton. Madame Modjeska bought cottage No. 3 on the island from Sam Tustin in June 1908.

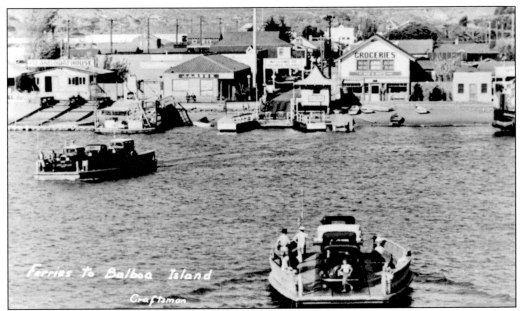

THE FERRY BETWEEN BALBOA ISLAND AND BALBOA FUN ZONE, 1937. Regular ferry service began in 1906, but service was erratic until the contract was granted to the Beek family in 1919. Their first ferry was named *The Ark* and carried oars in case of motor failure. Passenger fares were 5¢ per person. In 1931, the passenger fares were still 5¢ per person, and 50¢ for a car (including fare for the driver). Note that the near ferry is going to Balboa Island, and the far one will be landing at the Fun Zone in Balboa. The Beek family still has the contract for the ferry.

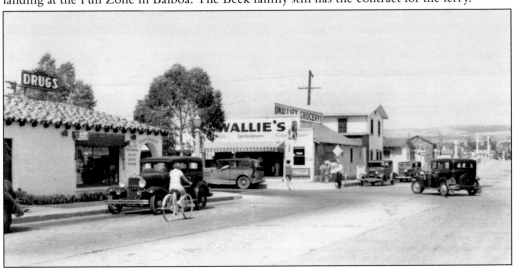

BALBOA ISLAND, CORNER OF PARK AVENUE AND MARINE STREET, 1935. This scene shows two of the three main streets on the island. The cyclist is on Park Avenue. William S. Collins created Balboa Island (1904 to 1907) out of mudflats by dredging, but improvements to make it habitable were not completed until 1911. Lots were advertised for as little as $25. It was later discovered that there was inadequate tidal protection and an unsatisfactory sewer system. When it was annexed to Newport Beach in 1916, the mayor announced, "The Island is a dump. It was sold by a lot of damn crooks to a lot of damn fools." Fortunately this has been corrected, and life on "Bal Isle" is highly desired for its village atmosphere.

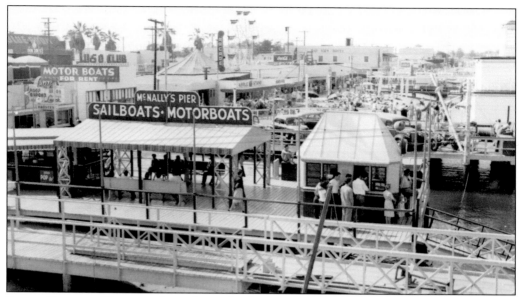

SPORT FISHING. The scene above shows the dock with the Fun Zone in the background. Sport fishing began in the 1920s and was a major source of income. Visitors came from throughout Southern California to enjoy the fishing offered here. Boats going out from Davey's Locker and Norm's Landing caught more fish than any other sport fishing center in Southern California.

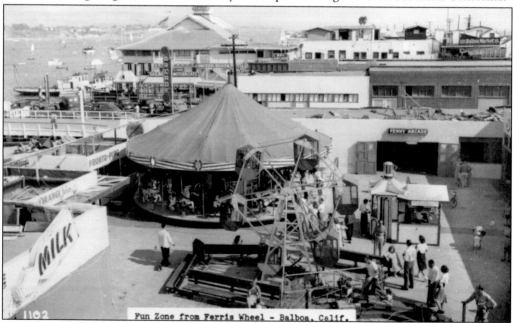

Fun Zone from Ferris Wheel - Balboa, Calif.

THE FUN ZONE, 1950. This is the view of the Fun Zone from the Ferris wheel looking toward the pavilion. In 1936, Al Anderson leased the bay front area between Washington, Palm, and Bay Avenues from rancher Fred Lewis. He cleared the land and began putting up amusement features, adding new attractions each year. He called his miniature amusement park the Fun Zone. In the 1980s, the Fun Zone, once targeted for demolition, underwent redevelopment and reopened in 1986 with its Ferris wheel and merry-go-round intact, but surrounded by new shops and restaurants.

THE PAVILION, BAY CITY (NOW SEAL BEACH). Shown here about 1910, the building was one of several constructed near the Seal Beach Pier and used for various functions such as dances and gambling. The pavilion burned down twice and was demolished in 1916 to build an amusement complex known as the Joy Zone.

BAY CITY, ANAHEIM LANDING, 1910. This old warehouse at Anaheim Landing was not needed for storage after the Southern Pacific came to Anaheim. The warehouses were converted to a bathhouse, a bowling alley, and a grocery store, which had "ice cold drinks cigars, tobacco, and candy." The bathhouse had a lunchroom, advertising "Hot Dogs and Coffee." Tents were erected in this area and became very popular in the summer. Water could be obtained from wells and hand-carried to the campsite. There was no interior plumbing in the small homes around the landing. The outhouses were called "castles," and each summer there was great hilarity as people moved them to new sites.

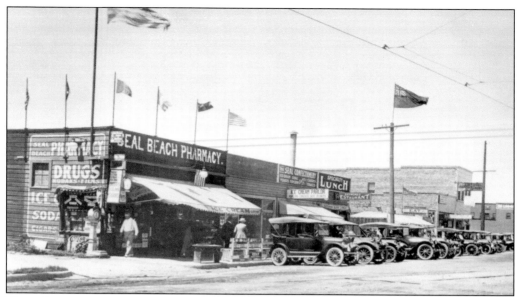

WEST SIDE OF MAIN STREET, SEAL BEACH. This 1920 view looks northward to Main Street. The Seal Beach Pharmacy advertised on the side of the building the availability of ice cold sodas, cigars, "Kodaks and Films" as well as drugs. Next to the pharmacy is the Seal Beach Confectionery selling ice cream, ice cream sodas, popcorn, Cracker Jack, peanuts, cigars, and tobacco. Beyond the confectionery is Raymond's Restaurant, featuring the "specialty lunch."

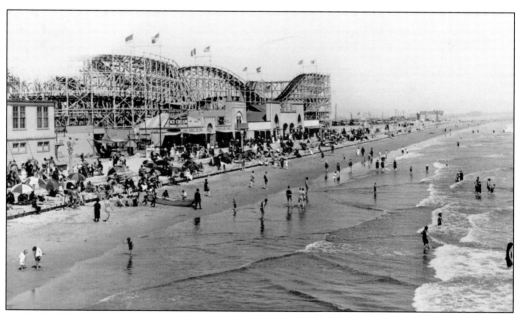

THE JOY ZONE AND ITS ROLLER COASTER NAMED DERBY. The Derby was originally at the Panama Pacific Exposition in San Francisco. When the Exposition closed in January 1916, the manager of the concessions, Frank Burt, came to Seal Beach to establish an amusement zone for "fun and frolic." Everything was dismantled in San Francisco, transported to Seal Beach, and reassembled. Tenants along the oceanfront were advised that they would have to relocate so that alterations on the pier for the Joy Zone construction could be started at once.

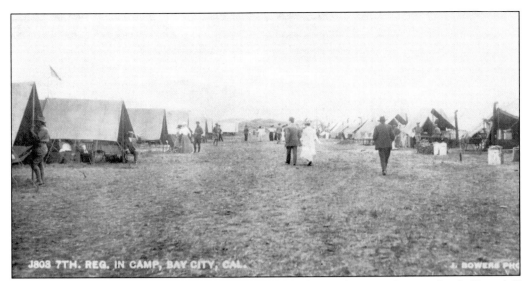

ARMY CAMP AT BAY CITY. This California National Guard group, Companies A, B, and C headquartered in Los Angeles, undergo their two-week summer training in Bay City. Shown here, the tent camp welcomes Sunday visitors who stroll the grounds in this 1909 scene. According to records from the era, the correct name for this group would be battalion rather than regiment.

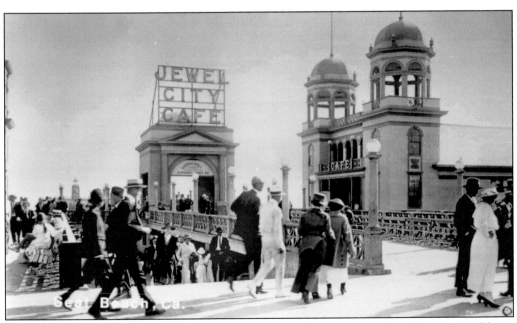

THE JEWEL CITY CAFE, 1920. This business opened on October 25, 1916, and could seat 500 diners. The food was "divine," and dancing through the night in the pavilion was "like gliding on glass." The sign over the entrance says, "Bathing Girls Fashion Parade Sunday, July 15th (1917)." Visitors came on Red Cars from all over the Southland to experience the many pleasures of the Joy Zone.

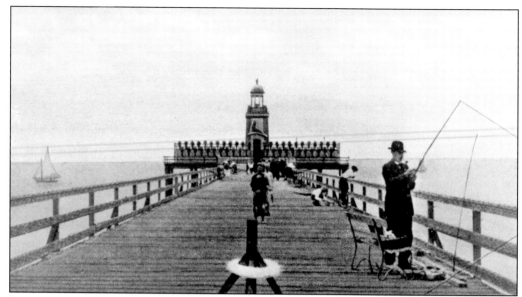

SCINTILLATOR LIGHTS, C. 1917. These scintillator lights, part of the Panama Pacific Exposition, were brought to Seal Beach and installed at the end of the new pier, which was constructed to be strong enough to hold the generator for the lights. This pier, like the old one, was 1,865 feet long and the longest pier south of San Francisco. During the era of these lights (1916–1930), the end of the pier was off limits because of the high voltage. Mounted on poles, the rainbow colored lights could be turned in all directions and could be seen as far away as 20 miles.

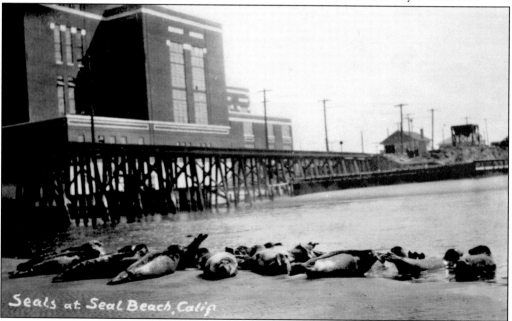

Seals at Seal Beach, Calif.

BASKING SEALS. Seals on the beach inspired the name Seal Beach, changed from the original Bay City to avoid confusion with San Francisco. The large building in the background is the Los Angeles Department of Water and Power electric generating plant. The seals bask on the beach here in 1915. With the increased boating activity and people on the beach, the seals have retreated and can now be found around the coast guard buoys off shore.

SUNSET BEACH BOARDWALK. The boardwalk is along Sunset Beach with the pier and cottages in the background. Golden State Realty Company produced an advertising brochure around 1910 to extol the virtues of its Sunset Beach properties. The brochure states, "Only a few years ago, Sunset Beach was laid out as a townsite and family resort. The high standard maintained has met with popular favor as evidenced by the tasty cottages that lend to the attractiveness of this thriving community."

"BATHING AT MEAN TIDE," 1911. A few vacationers are braving the waters, while others are observing them with interest. In the background sits "a cafe under competent management [that] caters to the wishes by supplying meals à la carte throughout the day with dinner from 5–7 p.m., family style." A delicatessen is also stocked with "appetizing stores."

NORTH LAGOON, 1911. Shown here is a house and boat dock on the North Lagoon, which afforded residents and visitors a tranquil recreational area away from the surf. Sunset Beach is a one-mile sandspit, 300 yards wide, between the ocean and tideland northwest of Huntington Beach.

DUCK HUNTING. There were many duck clubs in this area as marshlands on the coast, from Huntington Beach to beyond Seal Beach, made an ideal habitat for migratory ducks. Duck season brought many hunters. An early eatery in Sunset Beach was Barney's Beanery, on Pacific Coast Highway (PCH). The beans were famous up and down the seashore. The secret ingredients that made these beans so tasty and unique—duck meat and duck fat. The building is still on PCH and is now the King Neptune Bar.

Five

SOUTH COAST
DANA POINT/CAPISTRANO BEACH, LAGUNA BEACH, AND SAN CLEMENTE

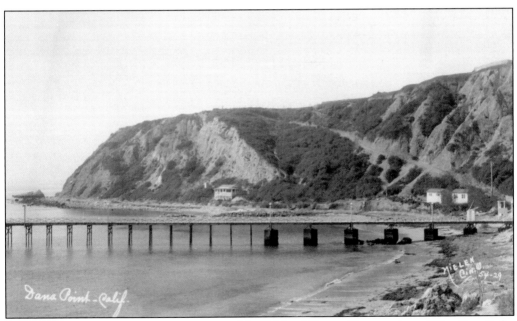

DANA POINT, 1924. Dana Point was named for Richard Henry Dana, author of *Two Years Before the Mast*; he described the area in great detail in his book. Hides were "hurled over the cliff so they could be loaded on the boats at anchor off shore. On occasion he had to scale the sheer wall to remove hides caught on the rocks." The 1920s development in Capistrano Beach and Dana Point was due to the vision of Edward L. Doheny, Anna Walters Walker, and Sidney Woodruff. The following postcards depict some of the items aimed at attracting buyers.

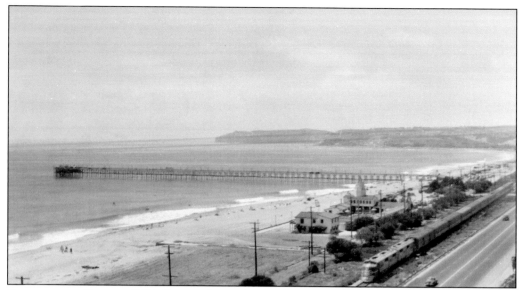

CAPISTRANO BEACH, 1950. From a tiny park atop the Capistrano Beach Palisades, a panoramic ocean view of curving Capistrano Bay is shown. The span includes Dana Point headland in the distance, the towered Capistrano Beach Club, and the 1,200-foot pier, which was a public fishing center for 40 years before being damaged by storms and then demolished. Note the Santa Fe streamliner, part of the "Surf Line" passenger service between Los Angeles and San Diego.

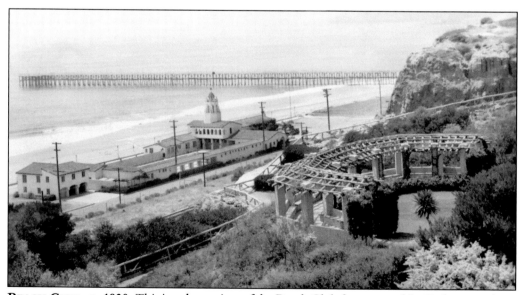

BEACH CLUB, C. 1930. This is a closer view of the Beach Club from part of the Doheny gardens. A stairway led through the gardens and the gazebo down to the road. The Beach Club became a major landmark; it went through several changes from nightclub to gambling casino and then to a semi-private club before it was dismantled in the late 1960s for a high-rise hotel that never was built. The County of Orange purchased the land and clubhouse after many legal battles. The building was demolished, and the area is now part of Capistrano Beach County Park.

DANA POINT LANTERNS, 1927. This is a Woodruff Syndicate promotional shot probably taken by Mack Sennett. The lady standing on the car is not identified. She is indicating to the lanterns for which the streets are named. Woodruff envisioned a "Mediterranean style mecca" and likened Dana Point to "the Rock of Gibraltar, created upon a solid substantial foundation. On the Pages of Time shall be written its achievements. Only on the ledgers of those who respond to the Voice of Opportunity will be written the profits to be made by early investment in this new, seacoast, recreational community."

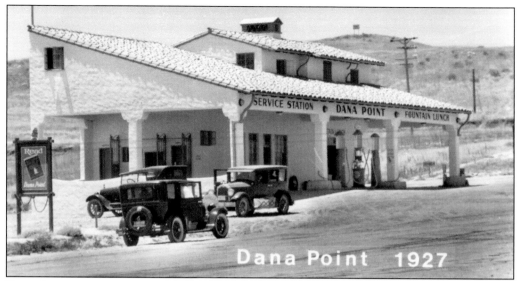

BLUE LANTERN FOUNTAIN LUNCH AND GAS STATION, 1927. The beach community's first development in 1924 brought about this business owned by Anna Walters Walker, a Laguna Beach realtor who was the tract sales manager. Located at the north entrance to Dana Point, it was the only gas station between Laguna Beach and San Clemente. Anna Walters Walker is thought to have named the town's quaint lantern streets, as well as having designed the gazebo behind this building (out of sight) as a promotional focal point. The tract was advertised as "Dana Point," formerly "San Juan Capistrano Point." The "San Juan Point Corporation" was formed in 1923 to promote what would become known as Dana Point. The building is still in existence.

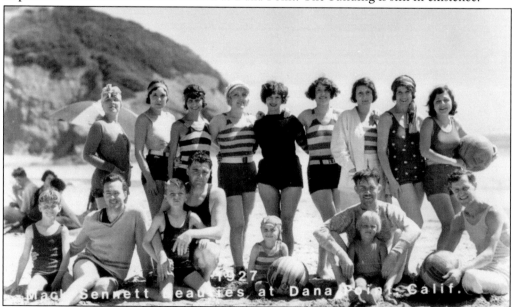

BATHING BEAUTIES. Mack Sennett was one of the investors in Woodruff's master plan for developing Dana Point and made promotional materials for company. Some other investors were actor Wallace Beery, as well as publishers of the *Los Angeles Times*, the *Examiner*, and the *Evening Herald* and others. This card shows some of Mack Sennett's friends relaxing at Dana Point Beach.

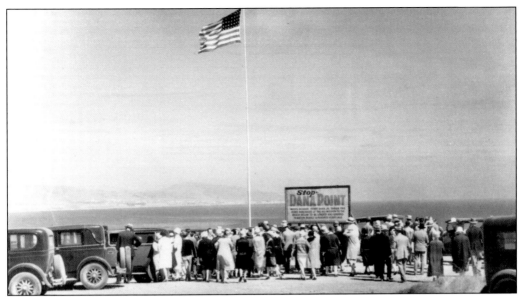

DANA POINT. This sign is part of Sidney Woodruff's attempt to attract buyers or investors in 1927. The sign says, "Stop. Dana Point. Where Richard Henry Dana threw the hides purchased at the old mission (San Juan Capistrano) to the beach below to be loaded and shipped to Boston nearly 100 years ago." Woodruff's description is colorful, if not quite accurate. The San Clemente coastline is in the distance.

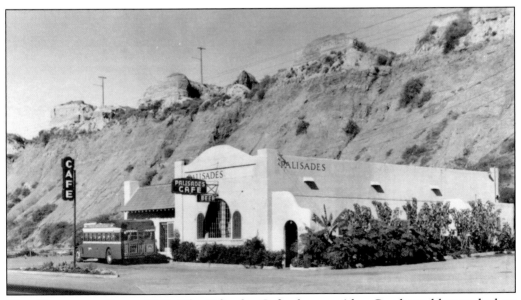

THE PALISADES CAFE, 1943. The Palisades Cafe, shown with a Greyhound bus parked on the side, was located near Doheny Park at 34790 Pacific Coast Highway, Capistrano Beach. In the 1930s, it was called Frank's Cafe and Bus Stop. The listing in the 1941 Orange County directory showed that the owner was Albert F. Harney, agent for the Pacific Greyhound Lines, phone Dana Point 272. In 1952, the listing is for G. N. Mathal, phone Dana Point 272. In 1954, the phone number was updated to Gypsy 6511. The cafe is listed in the directories until 1959, then it disappears.

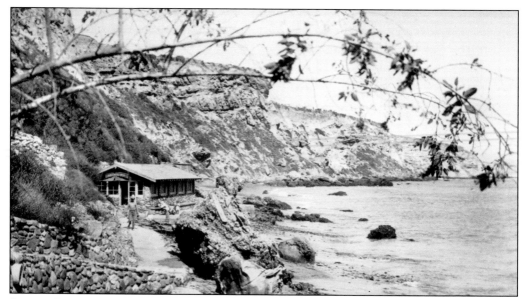

SCENIC INN, DANA POINT. It is not an inn, but a covered picnic area. Woodruff built this as part of his sales campaign. He would advertise a trip to Dana Point to see the development and, as part of the Dana Point Tour, a lunch was included at the Scenic Inn. This picnic pavilion was located in Dana Cove below the gazebo at the end of Street of the Blue Lantern. Prospective buyers descended by the stone stairway (bottom left) to this Scenic Inn to be entertained and fed by the Woodruff staff, and were encouraged to buy lots in the Dana Point development. High tides and neglect during the Depression destroyed the Scenic Inn.

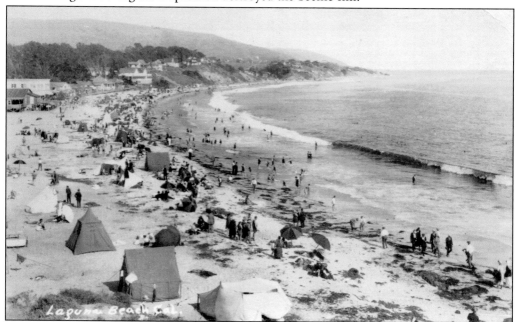

MAIN BEACH IN LAGUNA. Even before 1900, summer dwellers made good use of Laguna's Main Beach. Neither piles of uncleared seaweed nor the need for heavy cumbersome bathing attire kept people away. Soon a regular tent village arose behind Forest Avenue for those wishing spiffier digs with outdoor showers.

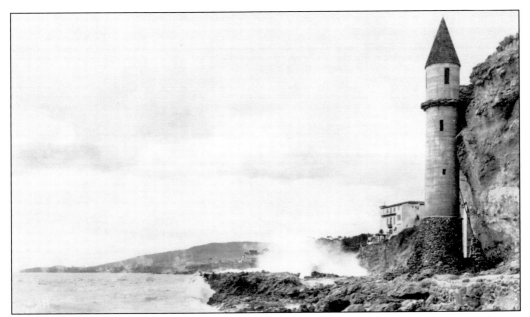

BROWN'S TOWER. A Registered State Point of Historical Interest, Brown's Tower stands on a rocky ocean ledge next to Victoria Cove in South Laguna. The tower, a 60-foot high staircase, connected the Brown mansion above with their outdoor seawater swimming pool to the ledge below. Remodeled in recent years, the tower still stands, but decades of pounding surf have all but destroyed the pool.

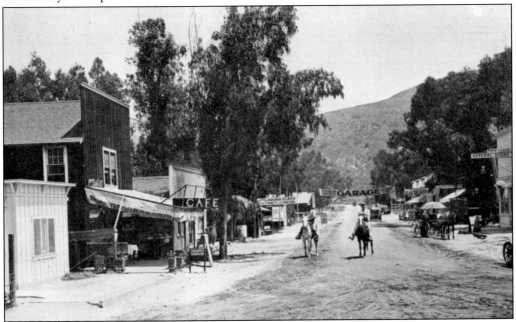

FOREST AVENUE, LAGUNA BEACH, 1915. Fred Clapp's general store is on the right, then the Laguna Bakery, and then Peacock's Garage and Stage Line. Roy Peacock was the second business to establish auto service to Santa Ana. The sign on the left side of the road is advertising, "Laguna Cliffs The Tract with Water." The first drinking water for Laguna Beach was hauled by wagon from the springs in the canyon. It was sold for 50¢ a barrel or 10¢ a bucket.

RANKIN'S CORNER. The first pharmacy opened in Laguna on Forest Avenue and was sold to D. L. Rankin in 1921. The business moved to the busy corner of Park and Forest Avenues facing the Coast Highway. It is most famous for its hanging gate. The words were taken from an English sign and read: "This gate hangs well and hinders none. Refresh and rest then travel on." The gate still hangs outside the current business establishment at the corner of Forest and Park Avenues.

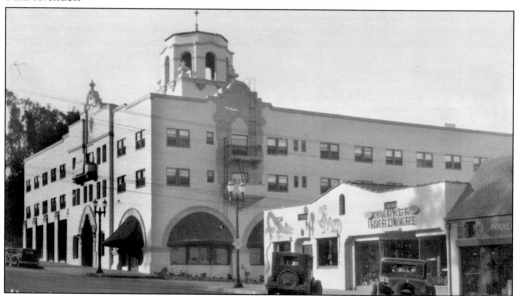

LAGUNA HOTEL. Replacing an earlier hostelry, the Laguna Hotel was opened at its current location in 1898 by Joseph Yoch. Locals attended Saturday night dances illuminated by kerosene lanterns. The hotel offered 30 rooms and a wide veranda overlooking the Main Beach; it was frequented by the famous Polish actress Madam Modjeska. Torn down in 1928, it was rebuilt and opened in 1931 with a mock bell tower and Mission-style parapets. The hotel became a destination for celebrities, including Charles Lindberg, John Barrymore, and Humphrey Bogart. Today its charming Spanish-style patio is the site of many weddings.

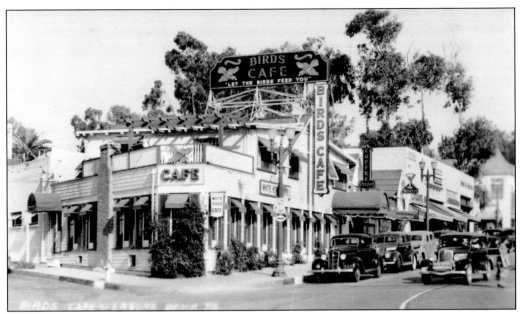

BIRDS CAFE. On the south corner of Park Avenue and Pacific Coast Highway (PCH) stood the Birds Cafe. Opened first as the White House Cafe, it was sold to the Bird family in 1918. The sign on its roof, visible to all motorists driving south on the highway, proclaimed "Let The Birds Feed You." It was a favorite stopping place for Bing Crosby on his way to the racetrack at Del Mar, near San Diego. It currently operates as the White House a few doors south on PCH and is the oldest operating restaurant in Laguna.

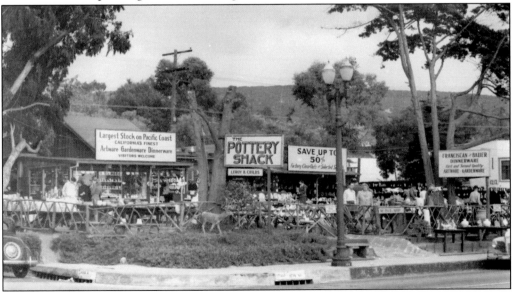

POTTERY SHACK. The Pottery Shack opened in 1936 in a log cabin that had served as a real estate office. Its rustic appeal has lasted nearly 70 years. The Pottery Shack promoted Brayton ceramics as well as other famous California potteries and at good prices. Soon other companies, such as Fiestaware, were added to the ever-increasing line of ceramics. South of the main village, its location on Pacific Coast Highway soon became a required destination for Laguna Beach tourists and pottery collectors alike.

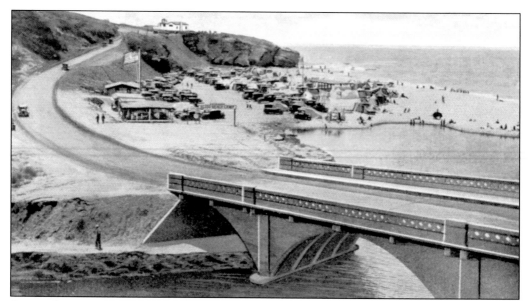

ALISO BEACH CAMP. In 1871, area pioneer George Thurston took over the Aliso Canyon homestead. Located several miles south of Laguna Beach, it was accessed only by a dirt road from El Toro. Offering a respite from the summer heat, the beach soon became a site for tent campers, with the Thurston family supplying food and other provisions. Even after the Pacific Coast Highway connected Laguna to San Clemente, Aliso Beach remained a popular summer getaway.

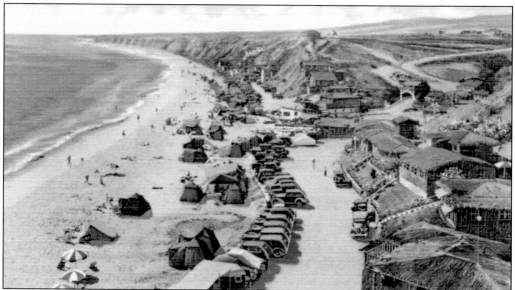

CRYSTAL COVE. Long appreciated for its beach and camping opportunities, Crystal Cove received its state park title in 1979. With 3.25 miles of white sand beachfront and 2,400 acres of land, the park was purchased from the Irvine Company for about $33 million. It lies between Laguna and Newport Beach and is the site of 45 beach cabins, some dating to the 1920s. The cabins are listed on the National Register of Historic Places as the last intact example of "vernacular beach architecture." The State of California is currently in the process of transforming the area into a modern tourist resort.

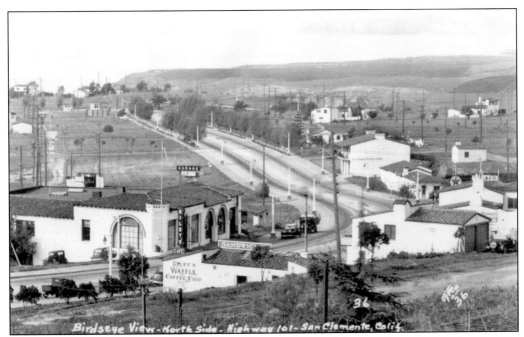

NORTH EL CAMINO REAL, SAN CLEMENTE. In 1937, looking north on El Camino Real at Palizada, even the commercial buildings followed Ole Hanson's romantic design for his master-planned "Spanish Village By the Sea." Each deed stipulated that the building had to be Spanish in style with a red-tiled roof and white-stuccoed walls.

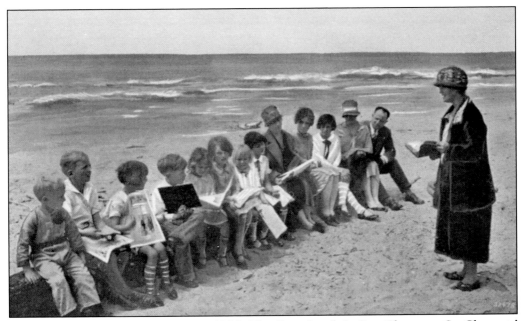

SUNDAY SCHOOL AT THE BEACH, 1926. The first church in San Clemente, St. Clements' Episcopal Church, was located on land donated by Hanson's company. Perhaps this Sunday School class is from the San Clemente Community Presbyterian Church, which had no permanent building. Members met in several places, including the Bank of America.

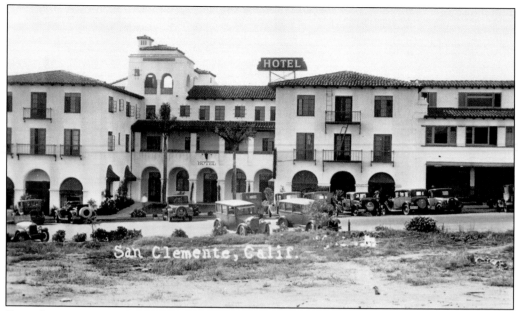

SAN CLEMENTE HOTEL, 1929. This hotel was constructed on Avenida Del Mar in 1927 and still is in use today. Sixty guest rooms were advertised at $2 and up. The hotel featured electricity on every floor and an elevator. Many of the rooms were occupied by families waiting for their new homes to be finished. In 1981, the building was placed on the National Register of Historic Buildings.

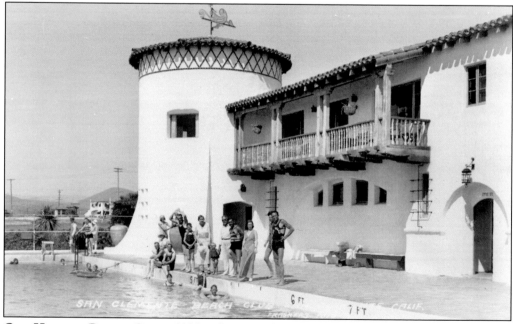

OLE HANSON BEACH CLUB, 1929. The San Clemente Beach Club, with an Olympic-size outdoor pool, was dedicated in 1928. This was one of the amenities provided by Ole Hanson for the charter lot purchasers. The club was used for tryouts prior to the 1932 Los Angeles Olympic Games. Johnny Weismuller, Duke Kahanamoku, and Buster Crabbe were among the famous athletes performing exhibitions of swimming and diving at this pool.

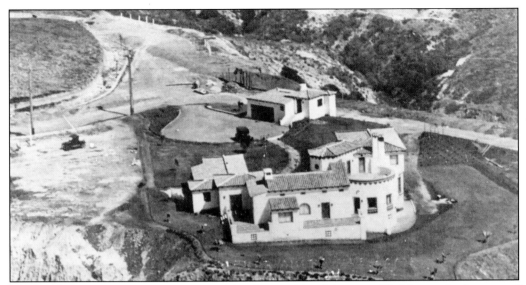

MAYOR TOM MURPHINE'S HOME, 1929. Thomas Murphine met Ole Hanson in the state of Washington while both were serving in that state's legislature. When Hanson became mayor of Seattle, he named Murphine as the city's superintendent of public utilities. They also worked together in Santa Barbara, Los Angeles, and on other real estate projects.

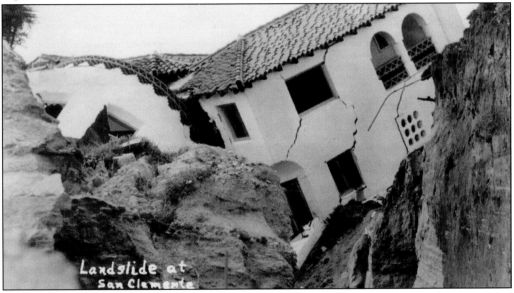

Landslide at San Clemente

ILL-FATED MAYOR THOMAS MURPHINE MANSION. Doris Walker describes the destructive event in her book, *The Heritage of San Clemente*. The mansion was "a lavish two story residence on Avenida de los Lobos Marinos overlooking a coastal canyon opposite Seal Rock. Three elements worked sequentially to cause the Murphine Mansion's demise." First the house stood on land with poor soil compaction. Landscape irrigation then further softened the soil. Finally the March 10, 1933, earthquake opened a cleft in the front lawn. The fissure widened daily. The family sensed what was coming and they pulled out as many belongings as they could onto the more solid back lawn. On May 5, "the house fell into the fissure, leaving the cliff section and front lawn momentarily intact." The cliff then slid onto the beach below, covering the railroad tracks in the process. This was an unfortunate final curtain for a beautiful house.

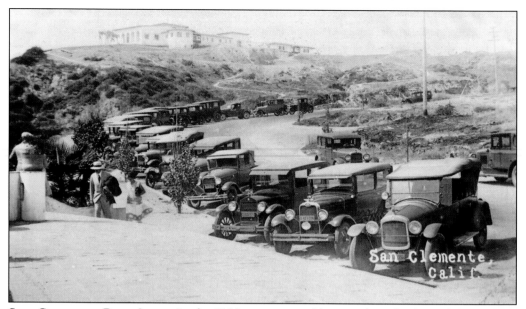

SAN CLEMENTE PIER AREA. In the 1930s, cars were able to park at the foot of the pleasure pier built by Ole Hanson in 1928. "Like most of Orange County's piers, San Clemente's was a favorite landing spot for Prohibition era rumrunners. A trap door under the small cafe at the end allowed the safe (but illegal) landing of booze out of sight from outsiders," writes Doris Walker. City founder Ole Hanson's Spanish mansion shows faintly on the bluff. Multistoried homes and condominiums there today surround the mansion. It is now owned by the city and serves as a cultural arts center.

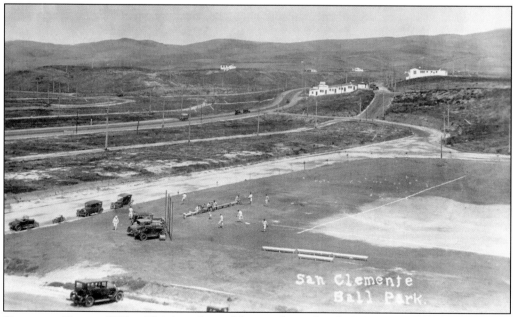

BASEBALL FIELD, 1930s. This is a view of the regulation baseball field across El Camino Real in North Beach near Ole Hanson's beach club. "Ole Hanson arranged for his former hometown's 'Seattle Indians' team of the Pacific Coast League to use it as their spring training site, offering them 'the world's best climate.'" San Clemente's baseball team played here.

Six

SOUTH
IRVINE, MISSION VIEJO, SAN JUAN CAPISTRANO, SANTA ANA MOUNTAINS, SILVERADO, AND TRABUCO

AGRICULTURE ON THE IRVINE RANCH. This is an image of farming operations on the Rancho San Joaquin portion of the Irvine Ranch. Dry farmland crops like barley and black-eyed peas were grown in this area. "At one time, the ranch encompassed 22 percent of Orange County (108,000 acres) which included some of the best farmland in the nation." James Irvine I acquired ownership of the land from his partners Flint, Bixby and Company, who made three major purchases of early land grants. The first acquisition was the Rancho San Joaquin from Don José Andrés Sepúlveda. The second purchase was a part of Rancho Santiago de Santa Ana and finally Rancho Lomas de Santiago was acquired. In 1886, James Irvine died. James Irvine II took control of the ranch in 1892 and, in 1894, founded the Irvine Company. In the background is seen the light-covered mesa on the lower knoll in the center of the postcard and a rock outcropping in the shape of a turtle with the head lifted. The rock can still be seen today. The rock gave this mesa its name—"Turtle Rock"—and is just east of the University of California Irvine campus.

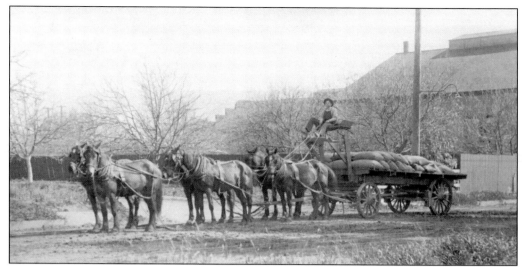

BEANS: BLACK-EYED OR LIMA? A wagon load of beans is delivered to a bean processing plant. This postcard was mailed from the Myford Post Office in Irvine to a Mrs. M. B. Webster in Ventura, California. On the Irvine Ranch in 1896, 1,800 acres were reserved for growing beans and leased to tenant farmers. In 1929, Orange County Farm Bureau reports show that 28,544,800 pounds of lima beans and 5,335,300 pounds of black-eyed beans were being produced on 34,350 acres in the county.

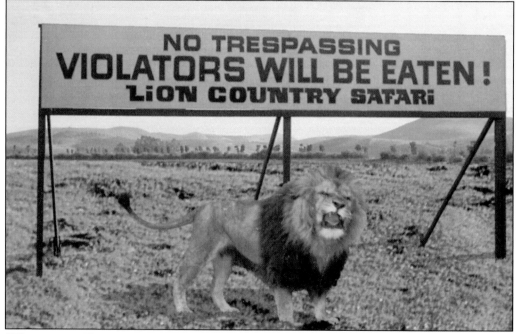

"VIOLATORS WILL BE EATEN." Between 1969 and 1984, Lion County Safari leased 500 acres from the Irvine Company for a drive-through wilderness park, located next to the 405 Freeway and the El Toro "Y" freeway junction. Automobiles with air conditioning were available to rent, however, most visitors used their own cars. Visitors were not allowed to bring pets and were instructed to keep their car windows closed. Frasier was the featured attraction for visitors and lionesses at Lion County Safari.

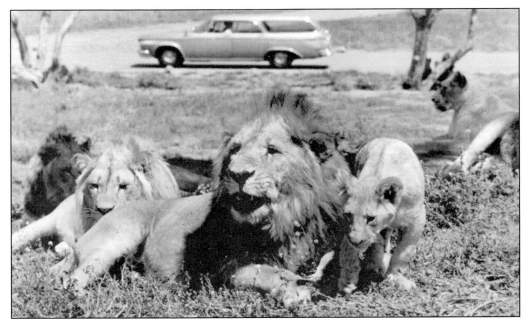

FRASIER "THE SENSUOUS LION." Advertising his prowess in increasing the number of lions, the theme park popularized Frasier as a symbol of virility. He sired 35 cubs in 18 months. Here he is pictured with some of his lionesses. Besides Frasier and his pride, the park featured elephants, zebras, giraffes, and an escape artist, Bubbles the hippopotamus. The park also included the Zambezi Riverboat Ride throughout much of the park. Admission was $4.95 for adults and $2.95 for children.

LA PAZ ROAD, MISSION VIEJO. La Paz Road was the first access road off the 5 (San Diego) Freeway into the newly planned community of Mission Viejo. This modern city was carved out of historic Ranchos Mission Viejo and Trabuco. Urbanization of this area began in the 1950s and accelerated by the 1970s. In 1988, it would incorporate as a city.

SAN JUAN HOT SPRINGS. Nestled in the Santa Ana Mountain range 13 miles east of San Juan Capistrano, these springs were first used by American Indians and, from the 1880s, by pioneers. In the 1930s, it was turned into a popular resort with cabins, a store, and a dance hall. The Orange County Health Department closed the resort in 1936 due to health concerns. The cabins were later moved to town.

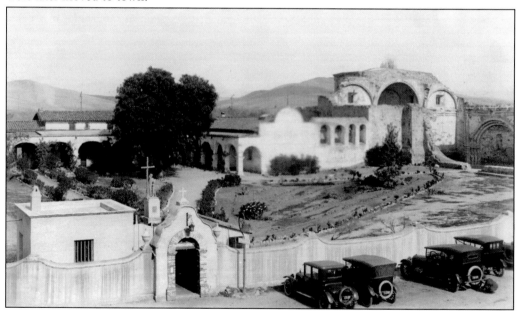

MISSION SAN JUAN CAPISTRANO. Built from 1797 to 1806, the mission was number seven in the California mission chain. In 1812, a major portion was destroyed by an earthquake. It was sold at public auction in 1845 and used as a private residence by the Forster family. John Forster was English and married into the politically prominent Pico family. Many of the buildings decayed over the years, but were restored by the Landmarks Club in 1895. The mission is a popular tourist attraction, whispering of the romantic era of Orange County's Spanish, American Indian, and Mexican past.

CAPISTRANO MISSION HOTEL, 1950s. Tourists visiting the historic Mission San Juan Capistrano could stay at the hotel just a few steps away. Today the Camino Capistrano Street is a busy thoroughfare although it looks much like it did in the 1950s. The hotel was built in 1920.

SAN JUAN INN CAFE. Built in 1918, this inn served the many travelers to the town, but burned down within a few years. The Capistrano Mission Hotel replaced the San Juan Inn Cafe. Tourism became a very important economic mainstay in town.

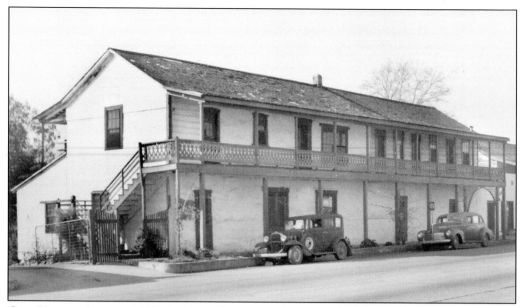

OLD YORBA ADOBE, 1940s. In the early 1800s, a branch of the Yorba family, originally from Spain, settled in San Juan Capistrano. Their adobe home still stands along busy Camino Capistrano and now houses boutiques and antique shops. The Yorba family owned several ranches in Orange County; their descendants still live in the area.

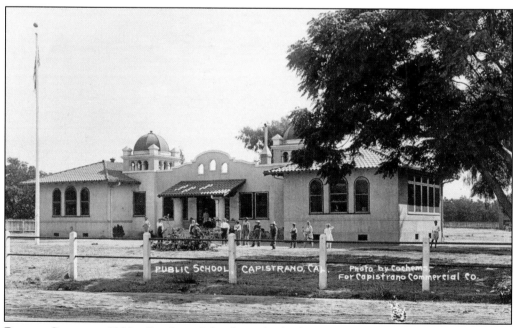

PUBLIC SCHOOL, 1920s. San Juan School was built about 1912 and stood until 1964. It was constructed in the same architectural style as the Santa Fe Depot and had two decorative bell towers.

SANTA FE DEPOT, 1930. Santa Fe trains brought travelers to the sleepy town of San Juan Capistrano. The depot, built in 1894, still stands today, serving as a picturesque location for a restaurant. The dome stands 40-feet high.

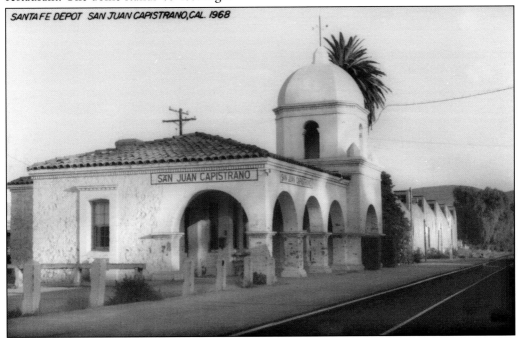

SANTA FE DEPOT, 1968. This building was the second depot or "new" depot. The Santa Fe Line had taken over the California Central Line and the chief engineer wanted a depot building that better reflected the mission's Spanish architecture. The first depot was Victorian in style with varied patterns of wooden siding and shingles, including an ornate, gabled roof. It was torn down in 1894, but its decorative windows were reused in a downtown building.

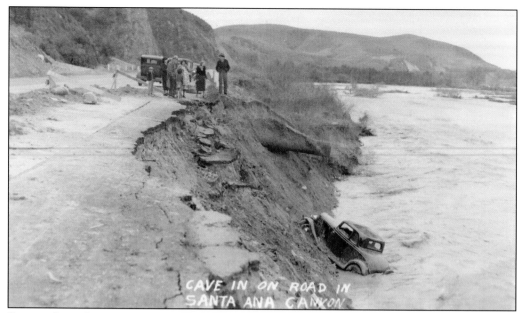

SANTA ANA CANYON. In 1938, Orange County experienced the worst natural disaster in its history. Swollen after five days of rain, the Santa Ana River poured over its banks and toppled bridges, destroyed homes, and ruined orchards. This view of the Santa Ana Canyon Road shows the devastation and destruction from that time. More than 50 people lost their lives to the flooding that year.

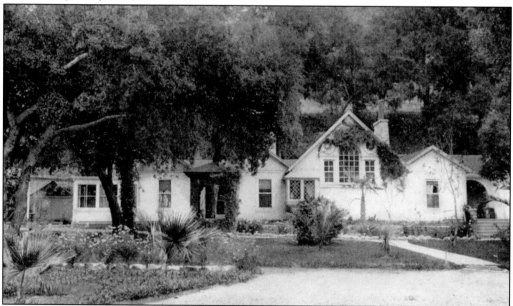

MODJESKA CANYON, SANTA ANA MOUNTAINS, 1915. This is the home of famed Polish Shakespearean actress Helena Modjeska and her husband, Count Charles Bozenta Chlapowski, who had purchased 640 acres in the canyon area by August 1888. They entertained many well-known guests in their canyon retreat. The actress used the porch as a stage on which to perform and entertain her guests. The home and grounds are now a historic park owned by Orange County.

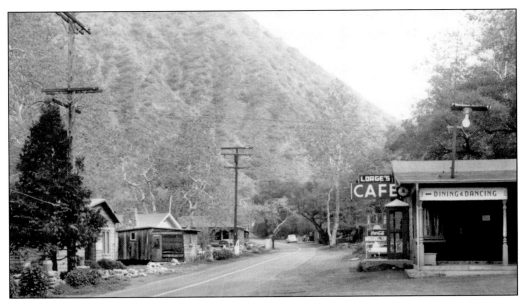

SHADY BROOK, SILVERADO. This settlement is in the canyon once called Cañada de la Madera (Timber Canyon). The name was changed when silver was discovered and, in 1878, it became a mining boomtown. At the height of its mining days, the population of Silverado topped 1,500. By 1882, mining had waned and the post office closed the following year. The area remains an easy-going canyon village with only a few businesses along its winding road. The "town" of Silverado in Silverado Canyon, is now a California Historical Landmark No. 202.

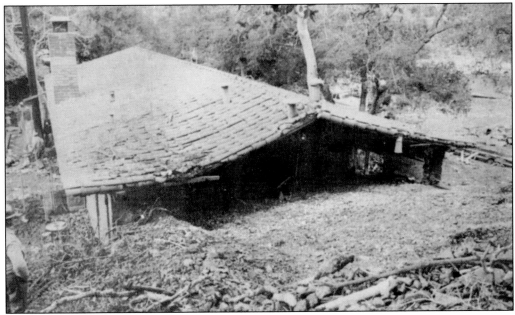

SILVERADO CANYON FIREHOUSE. In February 1969, this firehouse in Silverado Canyon suffered extensive damage. Five people lost their lives when a mudslide engulfed the building. Numerous others were injured as well.

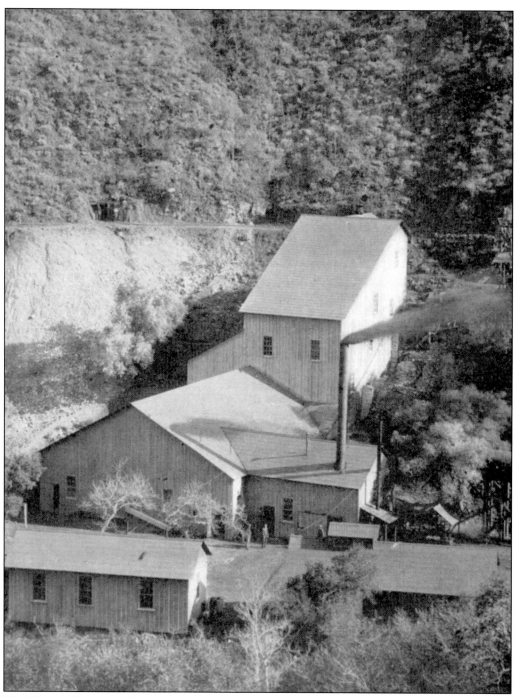

TIN MINE, TRABUCO CANYON. In 1877, A. Gasparina discovered tin ore and formed a mining district in Trabuco Canyon. There was no further activity until this mill was erected by the Santa Ana Mining Company about 1904. It was located in Trabuco Canyon four-and-a-half miles east of present-day O'Neill Park. When the owners, Gail Borden of New York and L. C. Comer of Los Angeles, cut exploratory tunnels, they found no tin, only traces of other minerals not worth extracting. This mine never lived up to its name.

Seven

Orange County
Government, Agriculture, Aviation, Health, and Recreation

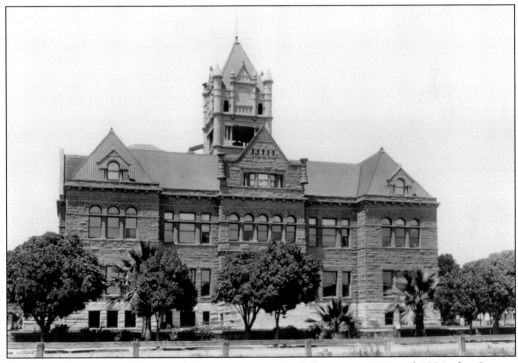

Orange County's Original Courthouse. Built between 1900 and 1901, the Orange County Courthouse was designed by architect Charles L. Strange of Los Angeles. It featured a concrete foundation, with granite from Temecula, and walls of brick from the Grouard's Brickyard in Santa Ana. Steel columns and girders supported the building. Red sandstone from an Arizona quarry was shipped in four-foot blocks weighing six tons each and cut to provide the facade of the building. The style of the building is called Richardson Romanesque. The original cupola on the roof made the courthouse the tallest structure in Orange County at the turn of the 20th century. However, after the 1933 earthquake damaged the building, the structural integrity of the cupola (which was unaffected by the earthquake) was questioned and it was removed.

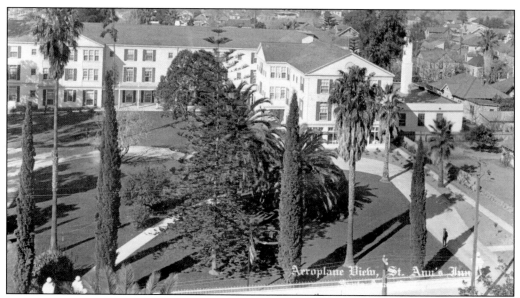

ST. ANN'S INN. St. Ann's Inn was a three-story wooden hotel, built during 1920–1921 by public stock subscription as a "first-class tourist hotel." Never a financial success, the inn was popular briefly with newlyweds. However, the state's imposition of a three-day waiting period in 1927 effectively killed the business. In 1930, Orange County purchased the property for $145,000. It was remodeled and in April 1931, began a new life as the courthouse annex. It was torn down when the new county administration building was built.

ORANGE COUNTY AIRPORT. Orange County Airport, formerly Eddie Martin Field, became a publicly owned facility in 1939 through a land swap between the Irvine Company and the County of Orange. After serving as a military base during World War II, it was returned to the County of Orange in 1946 by the federal government. Eddie Martin Terminal was built in 1967, and the County Board of Supervisors renamed the airport in 1979 to honor the movie actor John Wayne, a resident of Newport Beach.

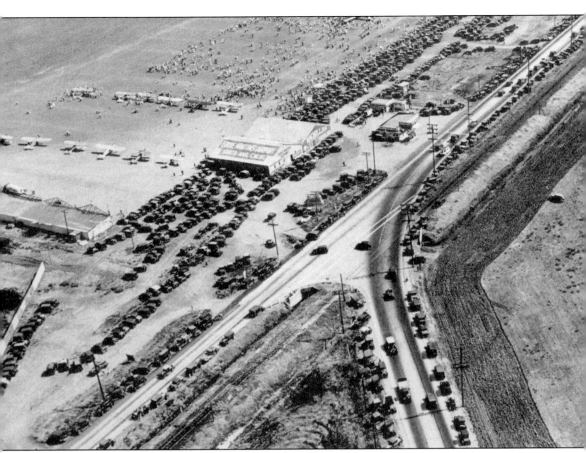

EDDIE MARTIN FIELD. This 1920s photograph shows the traffic jam created by an air show. Eddie Martin's dreams of a flying career began in 1912 when he saw his first plane at the old Santa Ana Race Track. His first flight was not until 1921, but by 1923, he had acquired a plane—a Curtiss JN-4 "Jenny" World War I trainer. To attract passengers, Martin moved the plane to an open field on the Irvine Ranch at the intersection of Main Street and Newport Avenue. When he finally got the courage to tell the Irvine family about his trespassing on their land, he found that James Irvine already knew about the unauthorized use. Irvine offered the young aviator a five-year lease on the 80-acre parcel. Eddie Martin's Airport and Flying School, the first permanent airport in the county, opened in 1923 with one Jenny and a piano box for storage.

SANTA ANA ARMY AIR BASE LOUNGE. From October 1941 through March 1946, over 150,000 men and women trained at the Santa Ana Army Air Base. It was the size of a small city, covering 1,283 acres bounded by Baker Street south to Wilson Street and Newport Boulevard west to Harbor Boulevard. It included 145 buildings, a theatre, a chapel, and a service club. The base served as an aviation cadet classification center and preflight training school. After World War II, the base became Orange Coast College, the Orange County Fairgrounds, and Tewinkle Park.

ENTERTAINERS BOB HOPE AND JUDY GARLAND. The Santa Ana Army Base service club was the site for many shows by entertainers such as Bob Hope and Judy Garland, pictured here in an Armed Forces Radio production.

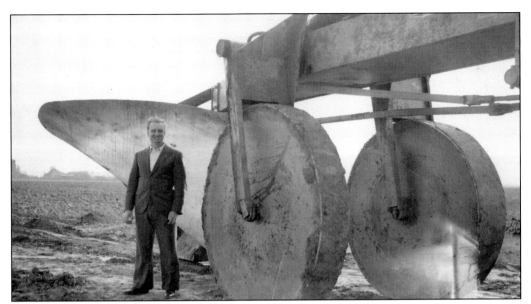

POST BROTHERS PLOW. The Post Brothers Plow, built in 1937, was used to reclaim farmland buried under silt from Santa Ana River floods. Weighing 13,000 pounds, the plow was 35 feet long and 12 feet wide. The top stood nearly 10 feet above ground level, and it was drawn by five tractors with D8 (six-cylinder diesel) engines generating 95 horsepower each.

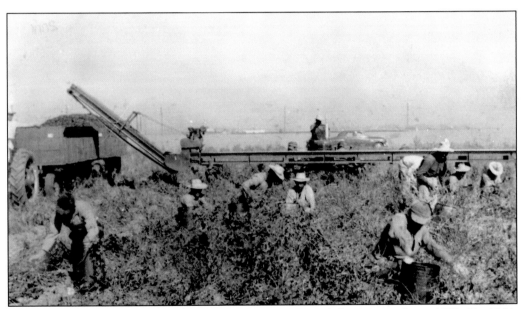

CHILI PEPPERS. Farmers near Anaheim began raising chili peppers about 1890. By 1901, individual growers were successful in drying their product. At one time, virtually all chilies grown in California were raised along Orange County's coastal plain. By 1980, none were grown commercially. This postcard shows the use of a conveyer to move picked peppers in bulk from field to the trailer, a "modern" improvement.

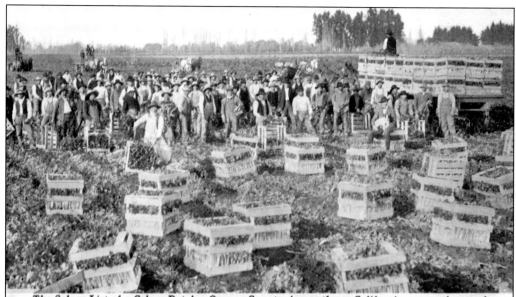

The Salary List of a Celery Patch—Orange County, in southern California, grows thousands of acres of crisp, white celery which always finds a rich and ready market.

USING ORANGE COUNTY FOR ADVERTISING, 1912 STYLE. The back of the card below tells the whole story.

POST CARD

UNITED STATES
AND CANADA
ONE CENT.

PLACE STAMP
HERE.

FOREIGN
TWO CENTS.

SECOND ANNUAL SUGGESTION.
February 23, 1912.
Aren't you coming to California this spring? The Golden State was never more beautiful, prosperous—attractive in every way—than it is this year. Big agricultural and industrial opportunities are awaiting the arrival of folks like you. The Southern Pacific is offering SPECIAL LOW RATES, from March 1 to April 15, 1912, in order that you may see our glorious western country. Why put off the trip any longer? Come out into the sunshine while the "coming" is good—and inexpensive! You'll never regret it—that's sure! Give us a suggestion of what you're interested in, on the attached card—please!
Yours contentedly,

YOUR SIGNATURE ONLY

ADDRESS

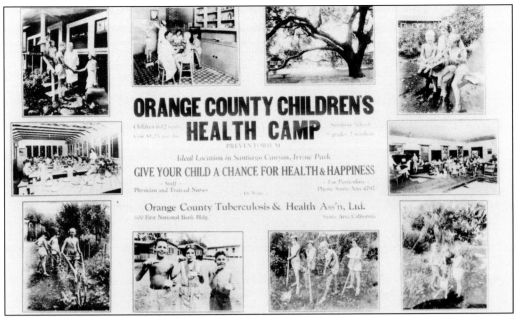

ORANGE COUNTY CHILDREN'S HEALTH CAMP. Located on 10 acres adjacent to Orange County Park (Irvine Regional Park), the camp began operation in 1926 by the Orange County Tuberculosis Association. Its purpose was to improve the health of children susceptible to tuberculosis, by using a combination of homegrown produce, exercise, and sunshine. The health camp survived until the Great Depression, having cared for 122 children, 95 of them discharged in good health.

ANCIENT OAK GROVE IN THE PARK. Orange County Park's (Irvine Regional Park) ancient oak grove was enjoyed by families and organizations as a gathering place for picnics and recreation. "Buds and Blossoms a promise of fruits and harvest will be the answer" is the quote on the card. This is a photographic postcard by Holland native Andries Nielen, who was famous for his artistic photographs of scenic wonders of the world.

ORANGE COUNTY PARK (IRVINE REGIONAL PARK). A meeting place for early settlers—then known as the Picnic Grounds—it became Orange County Park in 1897 when James Irvine donated 160 acres of prime oak and sycamore groves along Santiago Creek. In 1915, Santa Ana architect Fredrick Eley designed a 20-foot by 20-foot drinking pavilion that he called "Japanese Alpine." This style of architecture was also used on other park buildings.

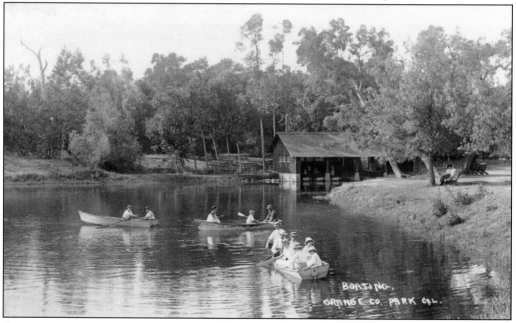

BOATHOUSE AT ORANGE COUNTY PARK. In 1913, Ed Stinson was contracted to excavate an old marsh in the park and create a two-acre lake. The oldest structure in Irvine Park is the 55-foot by 30-foot boathouse, built in 1914 by carpenters Cleland and Stewart. In August 1914, the boathouse provided cover for eight 16-foot, flat-bottom redwood boats. Ed Stinson was given the honor of the first ride.

O'NEILL PARK. O'Neill Regional Park was once a part of Rancho Trabuco, a Mexican land grant. The land eventually became the property of James Flood, a wealthy San Francisco businessman, and Richard O'Neill Sr., a former butcher and packinghouse owner. Built by O'Neill into a successful ranching enterprise, the land was divided among his children upon his death. In 1948, the O'Neill family donated 278 acres to the County of Orange. Subsequent donations enlarged the park to 3,100 acres. This 1955 postcard depicts the park's entrance.

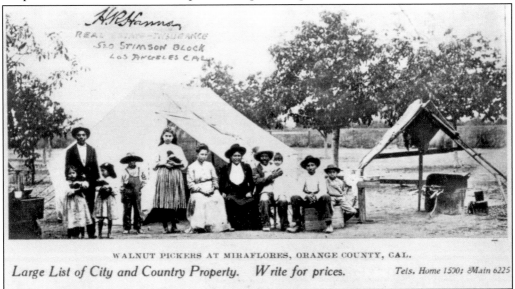

WALNUT PICKERS IN MIRAFLORES. A 1950s reproduction of an 1894 card issued by H. R. Hanna, a real estate dealer in Los Angeles, advertises county property for sale in Miraflores, Orange County, California. The view shows several families of walnut pickers at their camp in one of the area's walnut groves. Miraflores was an agricultural area consisting of walnuts, oranges, and other fruit trees, planted in the early 1890s. The Miraflores tract was located two miles southeast of Anaheim, east of present-day Harbor Boulevard, and bounded by Ball Road on the north and Katella Avenue on the south.

Other Publications from the Orange County Historical Society

www.orangecountyhistory.org

Berry, Roger B. and Sylvester E. Klinicke, compilers. Shirley E. Stephenson and Roger B. Berry, eds. *Centennial Bibliography of Orange County California*. Louise Booth, managing ed. Orange County Historical Society. 1989.

Carpenter, Virginia L. *Cañada de la Brea: Ghost Rancho*. 1978.

Dominguez, Arnold O. *José Antonio Yorba I*. 1967.

Meadows, Don. *The House of Bernardo Yorba*. 1953.

Orange County Historical Society (Barbara Milkovich and Esther Cramer, eds.). "Early Business in Orange County." *Orange Countiana* Vol. V (1992).

Orange County Historical Society (John Sorenson, ed.). *The Orange Blossom: 50 Years of Growth in Orange County*. 2000.

Orange County Historical Society (Richard Voelkel, ed.). "Architecture: A Window on the Past." *Orange Countiana, A Journal of Local History* Vol. IV (1989).

Orange County Historical Society. *Orange Countiana, A Journal of Local History* Vol. II (1980).

Orange County Historical Society. *Orange Countiana; A Journal of Local History* Vol. III (1982).

BATHING BEAUTIES OF BALBOA. The popular Orange County coastline was a favorite subject for postcards and captured the imagination of audiences of all ages in search of the California lifestyle.